BEAUTIFUL DEATH

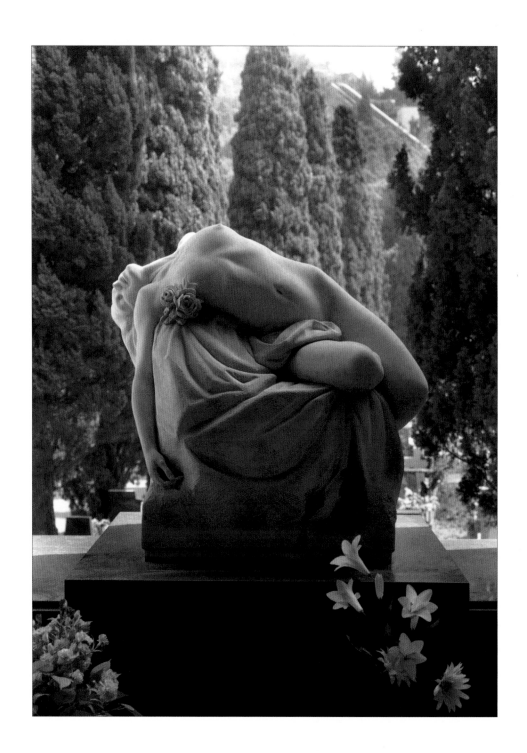

BEAUTIFUL DEATH

Art of the Cemetery

DAVID ROBINSON

with a text by

DEAN KOONTZ

PENGUIN STUDIO

PENGUIN STUDIO
Published by the Penguin Group
Penguin Books USA Inc., 375 Hudson Street,
New York, New York 10014, U.S.A.
Penguin Books Ltd, 27 Wrights Lane,
London W8 5TZ, England
Penguin Books Australia Ltd, Ringwood,
Victoria, Australia
Penguin Books Canada Ltd, 10 Alcorn Avenue,
Toronto, Ontario, Canada M4V 3B2
Penguin Books (N.Z.) Ltd, 182–190 Wairau Road,
Auckland 10, New Zealand

Penguin Books Ltd, Registered Offices:
Harmondsworth, Middlesex, England

First published in 1996 by Viking Penguin,
a division of Penguin Books USA Inc.

10 9 8 7 6 5 4 3 2 1

ISBN 0-670-86806-X
CIP data available.

Designed by Jaye Zimet
Set in Stemple Garamond
Printed in England

Frontispiece: Genoa, Camposanto di Staglieno

This book is dedicated to my parents

ALICE HOEBE KINNEY ROBINSON

Born June 7, 1897, Freedom, Wisconsin

Died June 25, 1978, Cleveland, Ohio

CLARENCE ADELBERT ROBINSON

Born June 9, 1899, New York City

Died July 26, 1982, Cleveland, Ohio

Acknowledgments

One of the powers cemeteries hold is the inducement to private meditation. They move us to reflect upon the meaning of our own lives as well as on the lives of those who have gone before us. Working on this book has given me ample opportunity to think about the lives of many friends, to appreciate them once again, and also to reflect upon the many mentors who have helped shape my own life. I cannot acknowledge here all who come to mind, but I am keenly aware that without the help of so many people, I would not be the person I am, nor the photographer —nor would I have been prepared to respond to what Père-Lachaise and other European cemeteries had to offer.

This book is dedicated to my parents; since they have no cemetery or gravestone, this book is offered as my commemoration to both of them. As parents, they not only gave me life, nurtured me and taught me, sustained and supported me, they also gave me the freedom—their blessing—to risk going against the grain when I was moved to do so. They never envisioned me as a photographer, but they came to embrace it because I did.

I have been fortunate to know many of my photography heroes as friends and to learn from many generous photographers who shared not photographic secrets but life lessons and simple friendship. One in particular, Morely Baer, died unexpectedly while I was finishing this book, and there are many photographs, particularly those of Prague, which make me think fondly of him. I also want to acknowledge two other photographers whose work I greatly admired even before I met them. Neither saw this body of work, but both influenced it. Clarence John Laughlin, a surrealist and a wonderfully imaginative photographer, was the first to get me interested in cemeteries, starting with those in his home town of New Orleans. Clarence was also the first to tell me of Père-Lachaise, many years before I got there. Although he died in New Orleans, his ashes are in Père-Lachaise, and there was no doubt that once I started this project I would pay my respects to him there. Aaron Siskind has inspired many photographers, and I am but one of the many. I never studied with him, except at lunch, but he was always responsive and ready to help. His breathtaking photographs, which reflect his devotion to the flat plane, the formal qualities of the picture, and abstraction, gave me courage to pursue my interests through the medium of photography. Aaron died while I was in Paris and, true to his conception of the universe, chose not to have a physical burial site. That will not stop any of us from remembering him.

I thank my wife for getting me to Paris and for making Paris so wonderful. As always, her enthusiasm was contagious and her advice practical. Salvatore Mancini has been a good friend and sounding board. For this book specifically, there are many who have helped along the way. Once again, I want to thank Martine Renaudeau d'Arc for her friendship, support, and guidance during the two years my wife and I were in Paris. I want to thank Dale Parker of Advanced Photographics for processing all the film while I was in Paris and making the exhibition prints for this series, and I thank Colorarts in San Francisco for preparing prints for this book. I am grateful to many who have shown this work, including La Maison Française at New York University, the Boston Public Library, the French Library and Cultural Center in Boston, the Boston Museum of Fine Arts, and the Robert Green Gallery. Again, I wish to thank the many people who have collected these photographs for their support.

My agent, Barbara Braun, deserves credit for making this book possible, as does my editor, Christopher Sweet, for actually making it happen.

I have been fortunate to work with a number of writers, on previous books, whose positive response to my photographs has been very gratifying. For this book, I wish to thank Dean Koontz for contributing such a personal essay. His introduction is eloquent testimony to the power of cemeteries, whether experienced in person or through photographs, to evoke deeply personal memories.

—DAVID ROBINSON

Contents

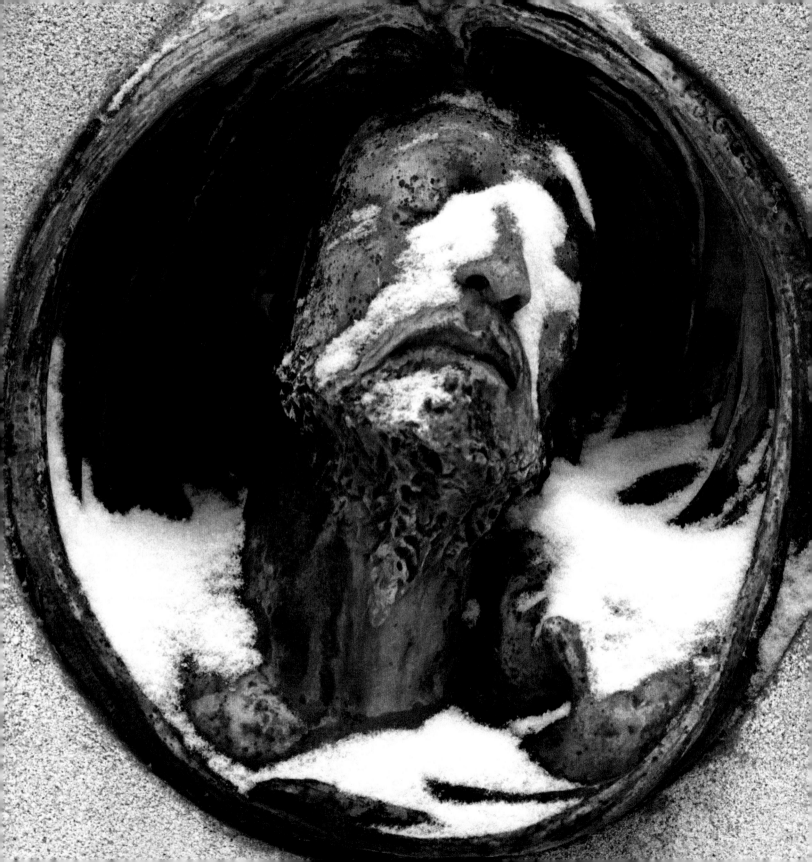

Beautiful Death

Dean Koontz

The cemetery photographs by David Robinson are filled with mystery, melancholy, sly humor, irony, hushed grief, the peace of final silences, sometimes a throttled anger at the fact of mortality, and even a strange wistfulness, but they successfully avoid fulfilling any of the usual expectations to which the subject matter might give rise. I see nothing frightening in these images, nothing morbid, nothing perverse, no calculated attempt to chill the spine by evoking primitive fears. Clearly the photographer understands that no resident of a cemetery is a fraction as fright-

Montmartre

ening as many *living* citizens whom one might meet, through the whim of a cruel fate, on any dark rain-swept street or on any sun-drenched avenue.

In warm oceans, coral reefs arise from the calcareous skeletons of certain marine polyps, which may or may not know of God. As the number of people who have died grows ever greater than the number currently alive, monuments to their memory accrete like reefs, and this cemetery architecture exists to express two hopes: first, that those we have loved and lost will not be forgotten; second, that they have gone forward from this imperfect world to a better place. David Robinson captures these hopes in his photographs—and allows us, depending on our mood, to be either lifted up by them or brokenhearted.

My mother's grave is in Pennsylvania, on a hillside shaded by evergreens. The double-width plot features a headstone designed to be shared by wife and husband. On the left side of this polished tablet is chiseled the name FLORENCE KOONTZ, the date of her birth, and the date of her death. She lived only fifty-three years, many of which were filled with worry and suffering.

The simple legend in the granite says nothing about the anxiety and anguish she endured; neither does it praise her selflessness and her great capacity to love. Like all of us, she lives, after death, not in monuments but only in the memories of those who loved her. The other half of the memorial face of that granite rectangle remains blank, and it will always be as smooth and uninscribed as it has been since it was erected. The space next to her is unoccupied, because I elected not to disturb her eternal peace by interring my father—and perhaps his restless spirit—beside her.

My father is buried in California, three thousand miles from that cemetery hillside in Pennsylvania. His ashes are contained in an urn, in an open-air mausoleum. My mother lies horizontally in the bosom of the earth, blanketed by pristine snow in winter, under a coverlet of grass in summer, while my father's remains are sealed in a vertical niche in a cold concrete wall faced with marble. The aptness of this did not occur to me until years after both of my parents were gone.

On her deathbed, struggling against the aphasia that was the consequence of multiple strokes, my mother managed to speak clearly fourteen words that will haunt me through the

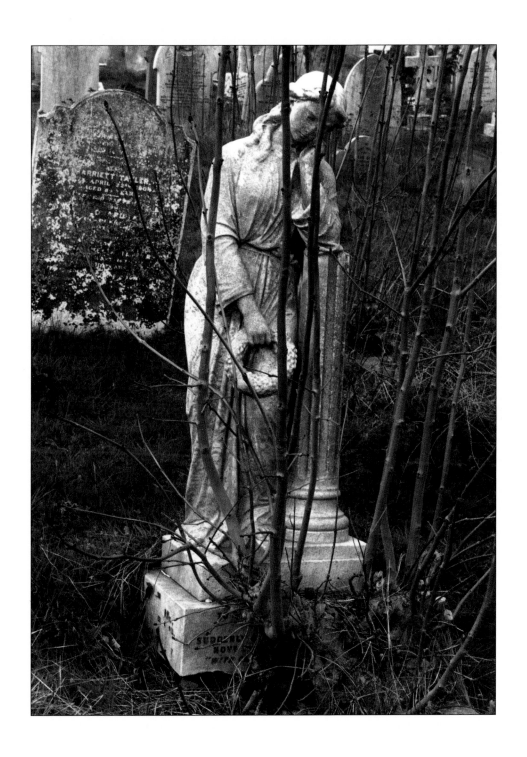

London, Chiswick

days that remain until I follow her out of this world. I was twenty-four at that time. I am fifty now. I have lived with those words longer than not, and I still recall the inflection of her voice as she spoke them: "There's something I've got to tell you about your father. You've *got* to know."

Then my father entered the hospital room.

My mother glanced fearfully at him, looked intently at me and at my wife, Gerda, and whispered conspiratorially, "Later." She died shortly thereafter, without sharing the secret that had briefly given her the will and the strength to speak clearly for the first time in weeks.

My father was an alcoholic, a gambler, a womanizer, and a pathological liar given to strange moods, spells of reptilian coldness alternating with periods of forced joviality, and fits of violence. Because of his drinking and because he occasionally punched one of his bosses, he held more than forty jobs in thirty-five years.

Life with him was sometimes a quiet hell, sometimes a shrieking bedlam. I dreaded the erratic fluctuations between those conditions more than either condition itself, for like all children, I craved stability. When fueled by fury and lubricated by the oleaginous self-pity with which he justified his rages, he shouted and stormed through our small house, red-faced, apparently believing himself to be a noble but misunderstood man only trying to do the right thing in a world where everyone was allied against him, as likely to burst into tears as to indulge his violent urges. During these episodes, although my father wanted to be seen as a suffering Job, worthy of unlimited sympathy, I could too easily discern his barely hidden glee in the tumult and destruction that he caused. Frightened, I prayed he would fall into one of his sullen moods, during which he might sit alone for hours without speaking, unapproachable, drinking beer, and performing routine maintenance on his fishing tackle. In these brooding silences, however, he was often more frightening than he was when in a rage; to me, his stillness seemed to be the quietude of a crouched predator, full of slyness and patience and grim need. The expectation of a new outburst was as distressing as—perhaps worse than—one of his rages, because long-term dread is depressing and exhausting. Among my earliest memories are sleepless hours spent in my dark, cramped bedroom, planning elaborate escapes or fantasizing about being shanghaied into a life at sea, perhaps with pirates, as if I believed that I were living in a previous century or in a novel by Robert Louis Stevenson.

Throughout my childhood, my mother protected me from some of my father's worst inclinations. Although only five feet two, gentle, thin, and eventually frail from lifelong medical problems, she was fearless about confronting him whenever it appeared that I might be physically harmed. Consequently, I could not imagine what secret she possessed that could make her unusually wary of him as she lay in her hospital bed during what she knew to be her last few days or hours of life.

My father outlived my mother by twenty-two years.

For fourteen of those years, my wife and I were his sole support. During this time, he was diagnosed as a lifelong borderline schizophrenic with tendencies to violence, complicated by alcoholism. The psychiatrist told me that Dad was "sociopathic and a pathological liar," which I knew from hard personal experience. I was informed that men of this type can be dangerous, especially when they are drinking, and that I was fortunate to have survived childhood with little physical abuse. I had not a single pleasant memory of my father; they were all dark. Nevertheless, because he was my father, Gerda and I felt that we should take care of him in his old age, though he remained difficult and, at times, threatening. With our father-son roles reversed, I was determined to treat him better than he had treated my mother and me. This was not evidence of honor or compassion on my part, but rather a need to prove to myself that I was in no way like him.

A few years before he died at eighty-one, long-term heavy drinking began to exact a greater toll; he suffered from degenerative alcohol syndrome, a pathological condition of the brain tissue, and from a stroke that robbed him of his ability to speak while leaving him with all his faculties and without paralysis. His violent episodes became increasingly extreme. Twice he attempted to stab me, and I was forced to take a knife away from him. This was not easy in spite of his advanced age, because he remained physically powerful even into his final year.

During this stressful period, my wife read a magazine article about early experiments in artificial insemination conducted in 1944, the year that I was conceived. According to this story, some of the initial trials were under the supervision of research physicians associated with a famous university hospital in Maryland. Because no one at that time was certain of the efficacy and consequences of artificial insemination and because it was controversial in some

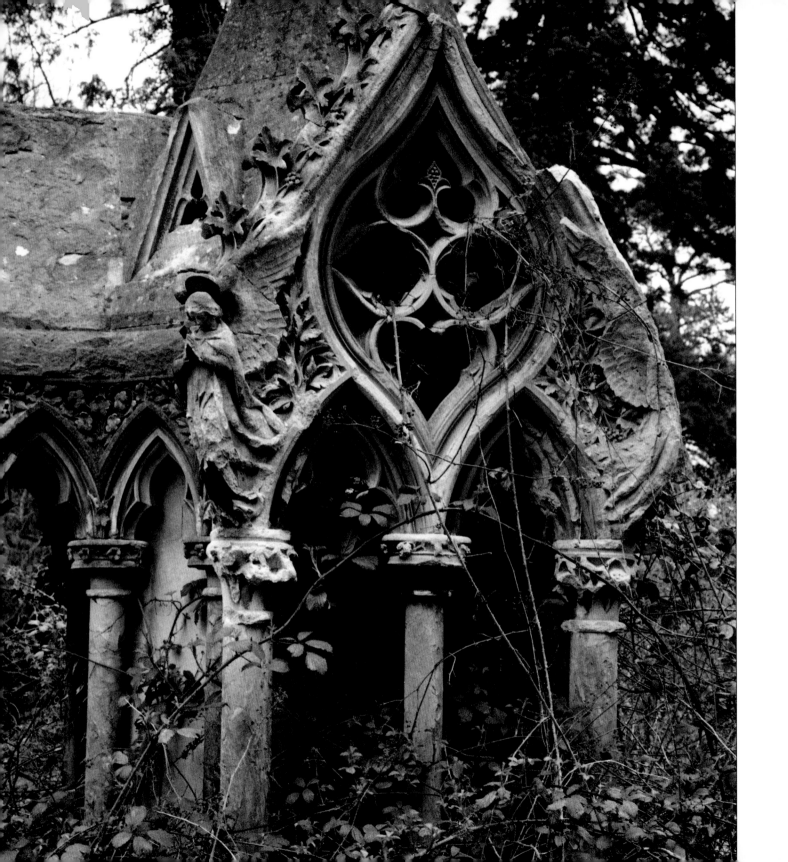

quarters, the physicians felt that discretion from participating couples was essential. The perfect subjects were deemed to be childless women with no more than a high-school education, from lower economic strata, and from rural communities in neighboring Pennsylvania, because psychological profiles predicted that these women would be embarrassed to discuss such an unconventional and—at that time—even bizarre process of fertilization and would, therefore, be more likely than more socially elevated women to honor confidentiality clauses in their agreements with the researchers. Idly at first and then with greater seriousness, Gerda speculated that I might be the product of one of these experiments.

The case she built for this prospect struck me as impressive, even if based entirely on circumstantial evidence. The chain of logic was intriguing. My parents had always called me a "miracle child," because I had been conceived after they had been told that they would never be able to have children. My father had been an indefatigable womanizer in an era when there had been no birth control, yet he had never, to our knowledge, fathered another child during any of his numerous infidelities, which made my conception even more miraculous. I bore no physical resemblance whatsoever to my father: I was six inches taller than he; Dad was large-boned and stocky, but I was slender and did not share his body type; no hint of his features could be seen in mine. No one in my father's or mother's families had shown any inclination toward a career in the creative arts—except that one of my father's brothers had been a good musician; on the other hand, the sperm donors involved in the artificial-insemination research at the aforementioned hospital had been famous writers, painters, and composers, from one of whom I might have inherited sufficient creative-writing talent to earn a living. Scores of smaller details, like mortar, seemed to cement these larger facts into a formidable theory, and Gerda became half convinced that I was not my father's son.

This could have been the secret that my mother had wanted to impart to me on the day she died. I would have liked nothing better than to have had this theory confirmed, because confirmation would have freed me from all concern that I might become more like my father, year by year, thanks to the irresistible force of genetic heritage. Since childhood, I had policed myself, on the lookout for signs that my own behavior in any way mirrored his, living with the quiet but

unceasing fear that I would *become* him with age. To know that we were not related by blood would have been profoundly liberating. I would have continued to support him in all ways until the end, but the fear that simmered in me, the fear of becoming in any way like him, would have evaporated. I would have been free.

Following my father's first—and least dangerous—attempt on my life, I considered asking his physician for a DNA workup on Dad and me, to determine if I was his son. I procrastinated for a year. I did not understand why I was reluctant to know the truth. In fact, I did not even realize that I was procrastinating. My work involved a long series of deadlines, and I pleaded the press of business each time that Gerda suggested proceeding with the blood tests.

Friends have suggested that perhaps I was reluctant to know that my legal father was not my biological father precisely because that discovery would raise not merely the possibility of artificial insemination but also the prospect of my mother's infidelity. My respect and love for my mother, however, is so great that no such discovery could diminish her in my eyes. She was a gentle, kind, and selfless woman who suffered a difficult life with dignity and good humor; poverty, abuse, betrayal, illness, cruel turns of fate—nothing could faze her for long.

And, in fact, as a child, I fantasized that my real father might be my Uncle Ray, who was married to Aunt Kate, my mother's sister. For one thing, I rather resembled him, and I looked so much like his son, Jim, that we might have passed for brothers. My Uncle Ray—a truck mechanic who was soft-hearted and loving and anyone's ideal of a father—spent more time with me than did my own father. His marriage was difficult, because Aunt Kate was exceptionally moody, perhaps even manic-depressive, and when I was eleven, I overheard my uncle and my mother in a conversation from which I inferred that they were in love.

Uncle Ray had come to our house in deep despair over something that Kate had done; indeed, he was barely repressing tears. I was sent on an errand, but I secretly lingered, listening to the two of them as they sat together on the back porch. At one point, he said, "How did it happen, Molly? How did we both marry the wrong person?" My mother said, "Don't talk about that. It's too late now. It's been too late for a long time." Uncle Ray was in tears: "It should have been me and you." She hushed him then, even though she thought I was gone, and said, "Don't

talk that way. Someone might hear. Anyway, it just makes everything worse."

If DNA tests had shown that my legal father was not my real father, and if an investigation of the records of that research hospital in Maryland had shown that my mother *was not* involved in those early experiments in artificial insemination, I would have been delighted to think that my Uncle Ray, fine man that he was, might have fathered me. Yet for a year after Gerda raised the issue, I procrastinated. Initially, I did not consciously realize what specific fear was inhibiting me from seeking the truth.

My father's second and more serious assault on me—a year after the first—occurred before numerous witnesses. While I successfully wrestled him for possession of the knife, the police were called. Dad was committed to a psychiatric ward until I was able to arrange for his care in a private facility that would ensure that he would not be a danger to himself or others.

During the following year, as Dad's health deteriorated, I continued to think about having blood tests conducted to determine our true relationship, but still I delayed. In his final months, he occasionally struck out at a nurse, or vehemently cursed the patient in the bed next to his, or shook his fist at me, and gradually I came to understand why I would never choose to test Gerda's theory. DNA comparisons might prove that I *was* his son. Thereafter, I would not be able to take consolation from the possibility that my real father was either a famous artist or my loving Uncle Ray. When Dad died and was cremated the evening of that same day, I was forever relieved from the hope of knowing.

The truth does not always set us free. Sometimes fantasy can enhance our lives more than science, self-deception more than truth. In the exercise of imagination, we can achieve liberation that can never be attained when we are encumbered by the leaden weight of cold facts.

Death, which took my mother, is not beautiful. He has the emotionless face of the unloving void, eyes as blank as polished granite, and a heart of maggots. Nevertheless, there is a strange beauty in Death's singular reliability as a keeper of secrets, in the perfection of his cowled silence. No man, woman, or child, regardless of how discreet, can be trusted to respect a confidence absolutely and for all time—a subject upon which I touched when writing a bit of verse as an epigraph for one of my novels.

Overleaf, Montmartre

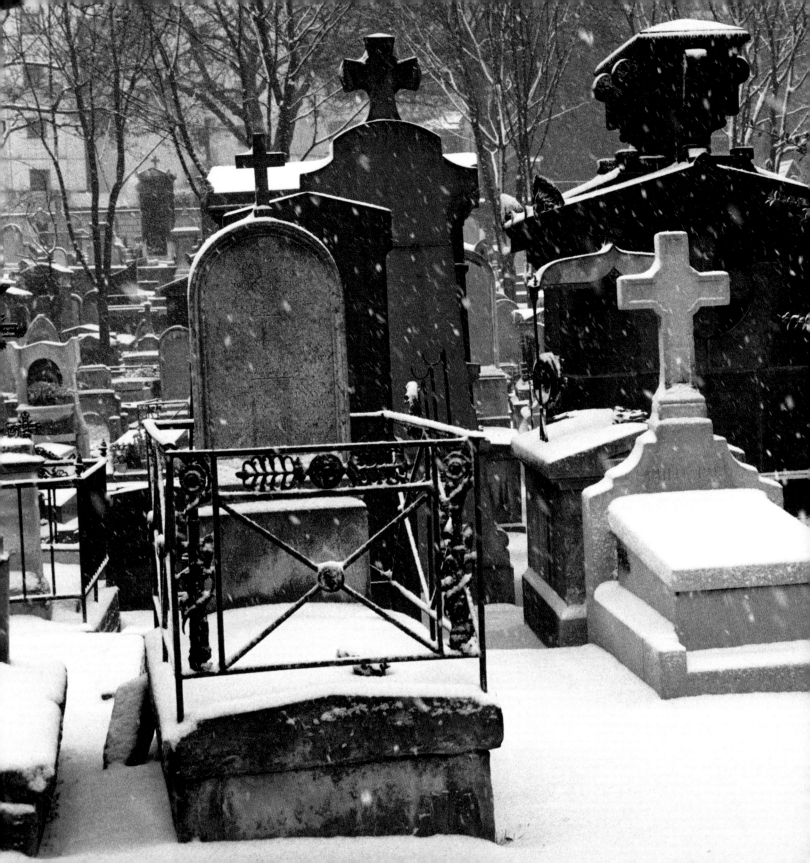

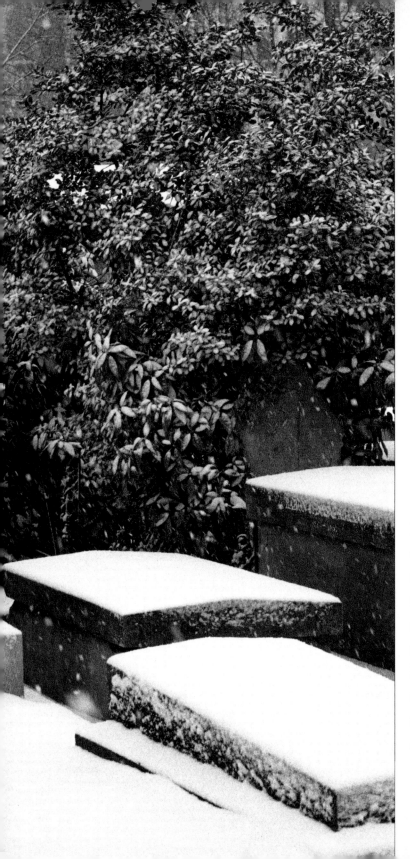

Nowhere can a secret keep
always secret, dark and deep,
half so well as in the past,
buried deep to last, to last.

Keep it in your own dark heart;
otherwise the rumors start.

After many years have buried
secrets over which you worried,
no confidant can then betray
all the words you didn't say.

Only you can then exhume
secrets safe within the tomb
of memory, of memory,
within the tomb of memory.

If my mother had been able to reveal her secret as she was dying on that icy February night, she might have forced me to reconsider everything that I thought I knew about who I was and about what my future held. Perhaps, at her bedside, I could have shed certain fears of paternal heritage with which I continued to live, instead, for another two decades. I might have been spared a recurring and extraordinarily vivid dream about my father and an ill-lighted cellar,

which wrung night sweats from me fifteen or twenty times over the years between my mother's death and his. But I have also considered that her secret might have been the key to a dark place, not information that would set me free but an unimaginable disclosure that would change my life for the worse.

Of course, not every deathbed statement is the seed of a great drama. The fourteen words my mother spoke to me might have been a preamble to nothing more than a truth already known to me, a truth that had acquired greater importance for her only because, in her post-stroke condition, she was not thinking clearly. Considering my father's lifelong behavior, however, I suspect a drama of one sort or another.

Regardless whether my mother's revelation would have been shocking or anticlimactic, fate decreed that she should not utter it. I believe in fate and grudgingly respect it. Fate works for the same master as death, and like death, it too is more fearsome than beautiful. As we travel toward our own headstones, we would be well advised to keep in mind that whatever land waits beyond the grave is no doubt less to be feared than the territory that we know on this side, in part because death and fate surely do not exist in that better realm.

All of us are travelers lost,
our tickets arranged at a cost
unknown but beyond our means.
This odd itinerary of scenes
—enigmatic, strange, unreal—
leaves us unsure how to feel.
No postmortem journey is rife
with more mystery than life.

Fate guided my mother to an early grave, where her headstone is plain and gray, not a thing of beauty. We were too poor to afford an imposing monument with pilasters and a decorative pediment and a carved granite wreath of acanthus leaves. When I stood in the cemetery and first saw the simple marker after it had been erected, I was sickened by an overwhelming sense of inadequacy, for it seemed to me that because of my inability to spend lavishly, the world would never know how gracious, kind, and brave she had been. I was younger than I realized. I believed in the value of monuments and was certain that stone had the power to preserve memory.

Over the ages, the rich have hired the finest artists to sculpt exquisite denials of the ugliness of death, while the poor have relied on cut flowers to beautify the final resting places of those whom they cherished. Flowers wilt and wither.

Stone darkens, crumbles; eventually it is overgrown with moss and lichen. No matter how much energy, labor, wealth, and passion we expend to make death beautiful, its ugliness is reasserted as decay inevitably progresses.

Beauty can be found, however, in the inability of death to take with my mother the love that she gave me. It is mine for as long as I live. And while I live, I try as best I can to repay her for that love by passing it on to my wife, who is as gracious and kind and brave as ever my mother was, and by sharing it with friends and family. Love is a legacy that the grave cannot tax, a legacy that grows, paradoxically, as it is spent generation after generation.

My father's anger and hatred and selfishness and sickness, on the other hand, is a legacy that the grave can keep. Certain deaths give us the chance to put cruelty behind us and find better lives than we knew before. We need only choose to bury the pain and to get on with living, choose not to dwell on it, choose to be healed, choose to condemn all hatred to the conquering worms and, by the way we live, celebrate only those who loved us and who were loved. In its ability to render hatred ultimately ineffective, as in its talent for keeping secrets, death sometimes reveals a terrible beauty.

By the time I reached my forties, I had stopped believing in the power of stone to preserve the memory of love, but I remained certain that words were timeless. I believed that deeply felt ideas and emotions would last forever if expressed with clarity and with passion. I am older now. I realize that Emily Dickinson and Walt Whitman and Milton and Donne and Shakespeare and Dickens will all one day be as unread and as unknown as lesser Peloponnesian poets who once celebrated the stars and the rigors of the heart but who are now lost in the mists at the edge of time.

In something like its current form, humanity has existed for hundreds of thousands of years, but recorded history covers only a fraction of that period. We have reached this point out of gray veils of mystery, as surely as we are doomed to proceed toward the greatest mystery of all. The world is troubled by endless cataclysms that inevitably abrade the past into dust from which we can sift no meaning. Wars and other human follies erase the past, but the most diligent force in the service of forgetfulness is nature herself. Two hundred and fifty million years ago, long before the apocalyptic event that caused the extinction of the dinosaurs, long before there *were* dinosaurs, a massive volcanic

eruption in that area we now call Russia apparently resulted in the extinction of ninety percent of the world's species, a sudden and violent transformation of the planet that makes the effects of human pollution seem like nothing more significant than the toils of a single ant colony. Such an eruption could happen again. Indeed, it will happen again, for the heart of the earth remains in dynamic flux, and no one can say if the end of all things will come next year or a hundred thousand years hence. All that is known is the inevitability of the volcanic blast, or the asteroid impact, or the abrupt shifting of the earth's axis, or the destabilization of the sun. The memory of love and the truth of any one life can be preserved in words for a while. But even the most crystalline sentences, full of truth so clear that each reader feels it like a piercing shard, cannot survive when paper burns, when the skies rain corrosive ashes, when thousand-foot tidal waves sweep continents clear, when grinding ice creeps relentlessly toward the equator. Perhaps the greatest beauty of words is not to be found in the observations conveyed by their meaning but in the faith with which we use them. I am deeply touched by the foolish courage of poets struggling, through their humble creations, to deny the void—though this is at best a melancholy beauty that does not bear long contemplation.

Life is a gift that must be given back,
and joy should arise from its possession.
It's too damn short, and that's a fact.
Hard to accept, this earthly procession
to final darkness is a journey done,
circle completed, work of art sublime,
a sweet melodic rhyme, a battle won.

Preserving the memory of the beloved dead—whether with words or stone monuments, if even for a time so brief as to be geologically insignificant—is valuable work. Each of us enters the world without possessions, and each departs in an equivalent condition of material poverty. The empires we leave behind are obliterated by time as efficiently as it reduced the wonders of Ozymandias to rubble and sand. Yet, if we have lived well, we also leave that legacy which seems ephemeral but which grows forever and which time cannot touch: the compassion with which we treat others, the kindness and love we give. When erected not out of obligation and tradition but out of a desire to remember those whom we have lost, gravestones and monuments symbolize our intuitive recognition that

no fortresses or cities or mighty nations are as enduring—or as *worthy* of enduring—as the kingdoms of the heart. Gravestones do not honor death but life; by erecting them, we try, in our fumbling way, to celebrate human relationships. A cemetery monument is a challenge to death and to remorseless time: *This* person will not be forgotten, the effects of *this* life are enduring and unassailable by entropy. Ironically, with a granite headstone, we declare the ultimate meaninglessness of all things material and the triumph of the spirit.

I believe in life after death. To me, eternal life is not an article of faith but an even more obvious fact than any of the laws of physics. The universe is an efficient creation: matter becomes energy; energy becomes matter; one form of energy is converted into another form; the balance is forever changing, but the universe is a closed system from which no particle of matter or wave of energy is ever lost. Nature not only loathes waste but forbids it. The human mind and spirit, at their noblest, can transform the material world for the better; we can even transform the human condition, lifting ourselves from a state of primal fear, when we dwelled in caves and shuddered at the sight of the moon, to a position from which we can contemplate eternity and hope to understand the works of God. Light cannot change itself into stone by an act of will, and stone cannot build itself into temples. Only the human spirit can act with volition and consciously change itself; it is the only thing in all creation that is not entirely at the mercy of forces outside itself, and it is, therefore, the most powerful and valuable form of energy in the universe. Thrifty nature will not allow it to be wasted. For a time the spirit may become flesh, but when that phase of its existence is at an end, it will be transformed into a disembodied spirit once more.

I have had only one experience that might be supernatural and that appears to argue for the existence of an afterlife. Until now I have never written of it, partly because I felt that to discuss it in the usual forums open to me would be to diminish it. Describing that incident here, however, in the context of this essay, feels right.

Two days before my father tried to assault me with a knife for the second time, I received a strange telephone call. I was at work in my office, and when I picked up the phone, I heard a faraway voice speaking with urgency. The caller was a woman, and she said, "Please be careful." When I asked who she was, she did not respond, but she repeated the warning three more times.

Although her voice faded with each repetition, she continued to speak with great urgency, and she sounded frightened. For a while I listened to the hiss of an open line, but at last I hung up. Although my mother had been dead for twenty-one years, and although it is immeasurably more difficult to remember a voice than it is to recall a face, I was more than half convinced that I recognized the caller's voice as that of Florence Koontz.

You will notice that I was "more than half convinced," but not certain. Certainty is the province of fools and zealots. My phone number was unlisted, however, and I have no friends who relish practical jokes of that nature. Perhaps someone misdialed and I only imagined that the caller sounded like my mother, but if that is the case, it was an astonishingly timely wrong number.

Because of that quiet but disturbing experience, I might have been more cautious than usual when, two days later, I visited my father. Perhaps that extra degree of caution spared me from the cutting edge of the knife and even saved my life.

In the years since I received that call, I have not thought about it often or at length. The meaning of the incident cannot be deduced by pondering the few facts or analyzing its relationship to subsequent events. It is simply a thing that happened, like the touch of a warm and reassuring hand in the darkness.

I must believe that when I leave this world I will eventually be with my wife, Gerda, again elsewhere, for it is intolerable to think that our relationship can be limited to the life span of the flesh. For me, to accept atheism would be to accept that life has no meaning or purpose, and the struggle to get through every day would be grimmer than the mindless striving of ants in the mazelike tunnels of their hills. If I precede Gerda through the doorway of the grave, I hope that I might be able to call back to her one day, as perhaps my mother called me, and remind her that I loved her in the world I left and will be there to love her in the world to which I have gone. And if she makes that passage before I do—a thought that terrifies and humbles me—I would hope to see an inexplicable reflection of her face in a stillness of water, or hear her laughter on a breeze, or feel the ghostly touch of her hand on a lonely night as she reaches out to me across the abyss.

If we go on from here into a land where existence is eternal and where fear is unknown, as I believe we do, then perhaps even death is

beautiful when it comes at the end of a full life. Then the grave is not a dark hole but a bright portal, and as H. G. Wells said in another context, "The past is but the beginning of the beginning, and all that is and has been is but the twilight of the dawn."

Hope is the destination that we seek.
Love is the road that leads to hope.
Courage is the motor that drives us.
We travel out of darkness into faith.

In the monuments we build to loved ones lost, we express a courageous hope that elevates us and makes our days in this world far sweeter than they could be without it. Because of the passion that David Robinson brings to his photography, we see in these images not merely his own art but the art of graveyard architecture. We see, too, the beauty of Creation, through which we travel from darkness into light and into darkness again—but surely also, thereafter, into light once more.

BEAUTIFUL DEATH

PARIS

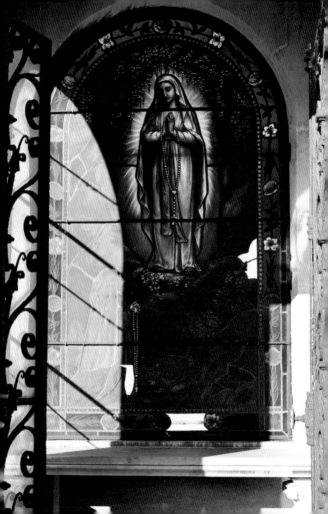

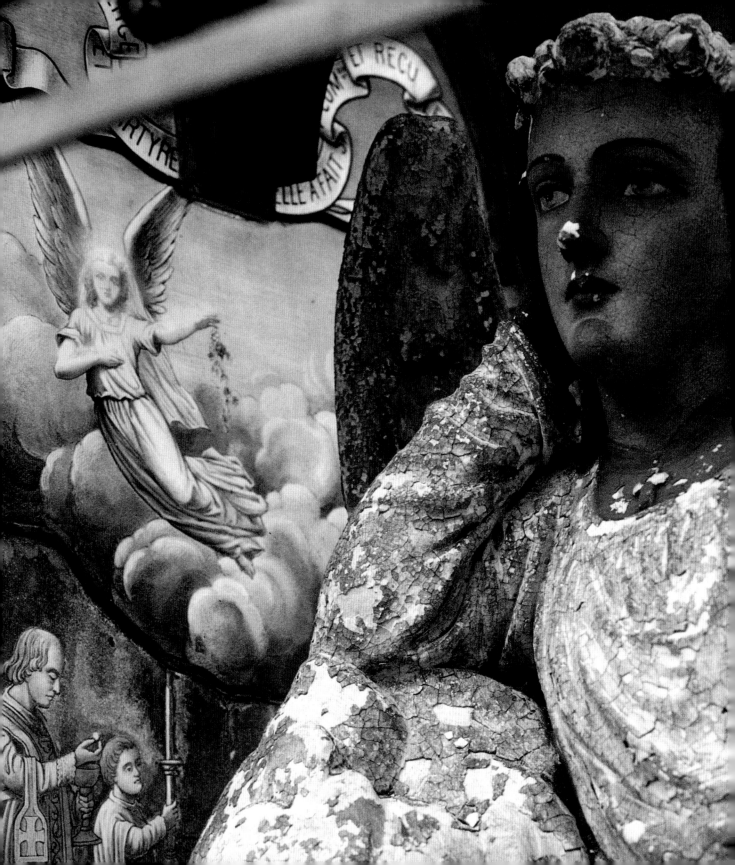

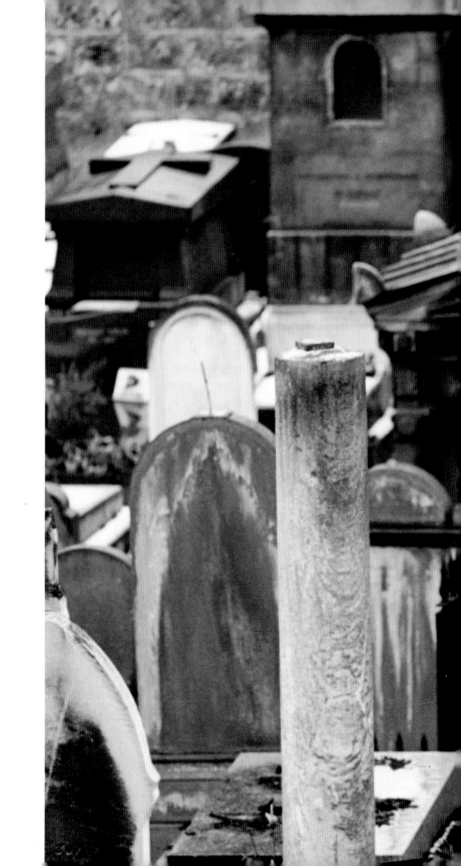

Père-Lachaise

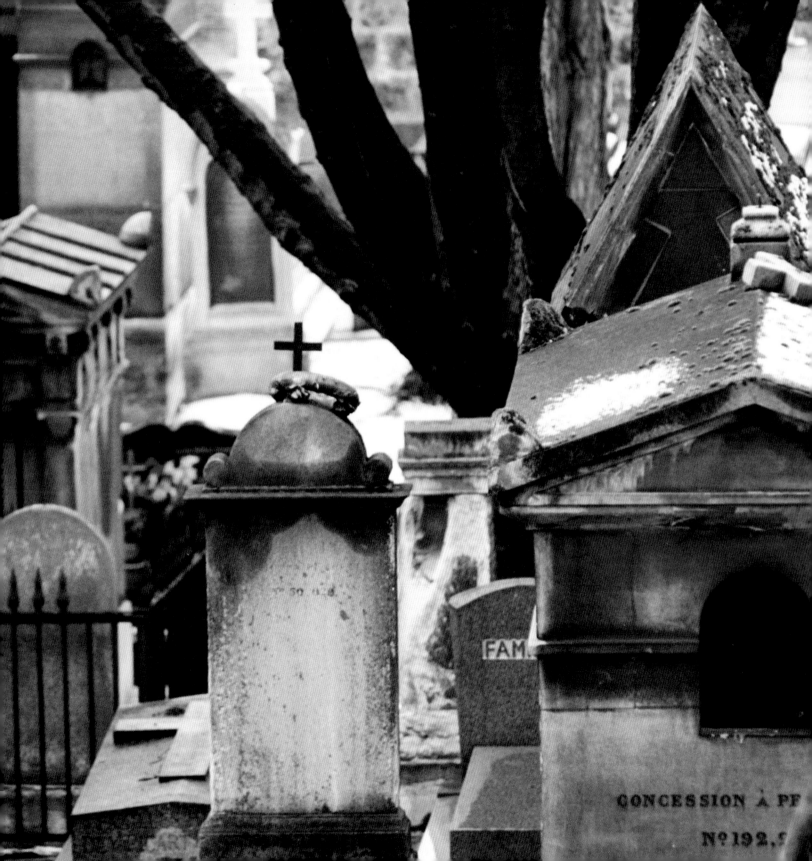

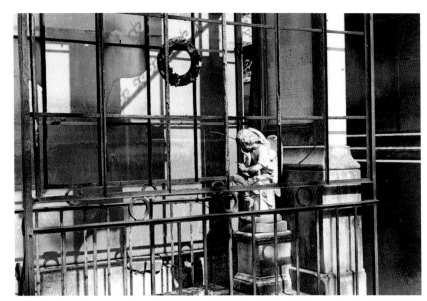

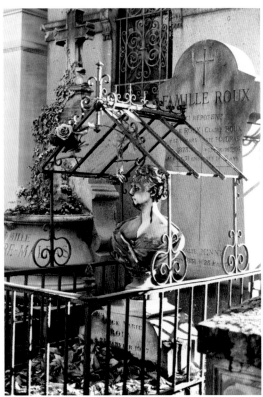

Père-Lachaise | Père-Lachaise

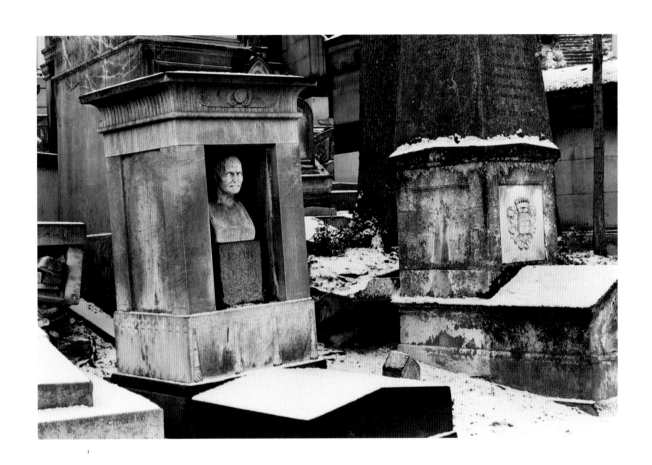

Overleaf: Père-Lachaise

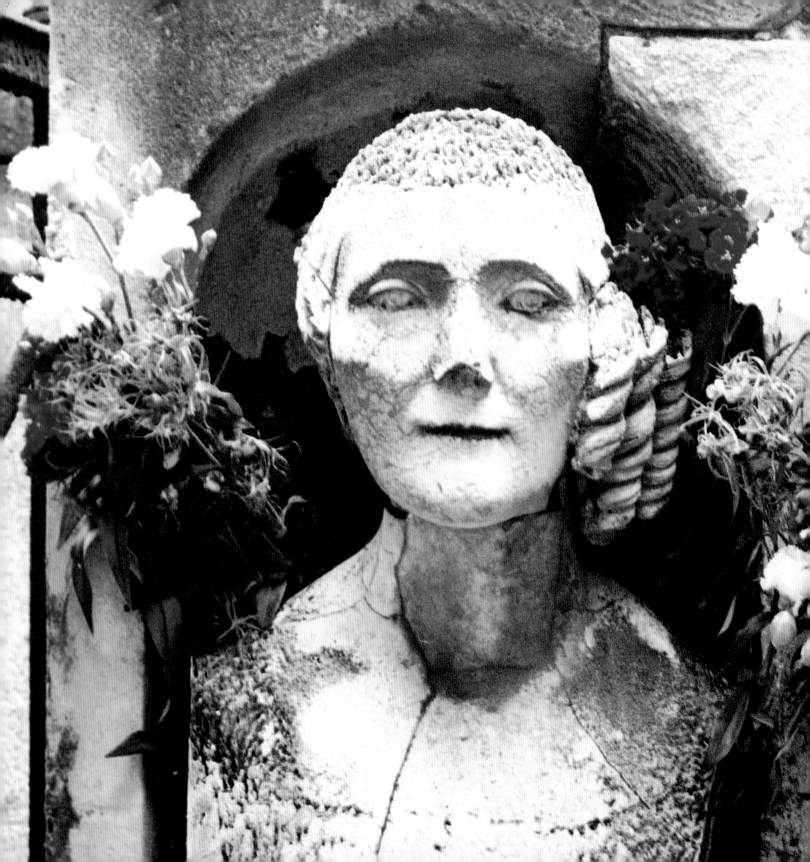

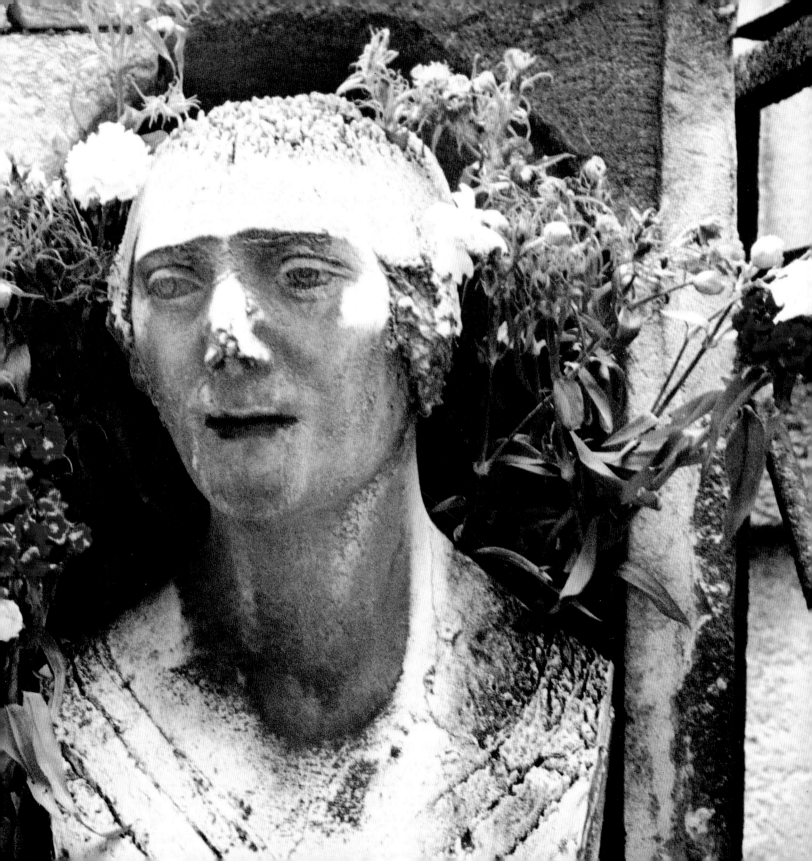

Père-Lachaise

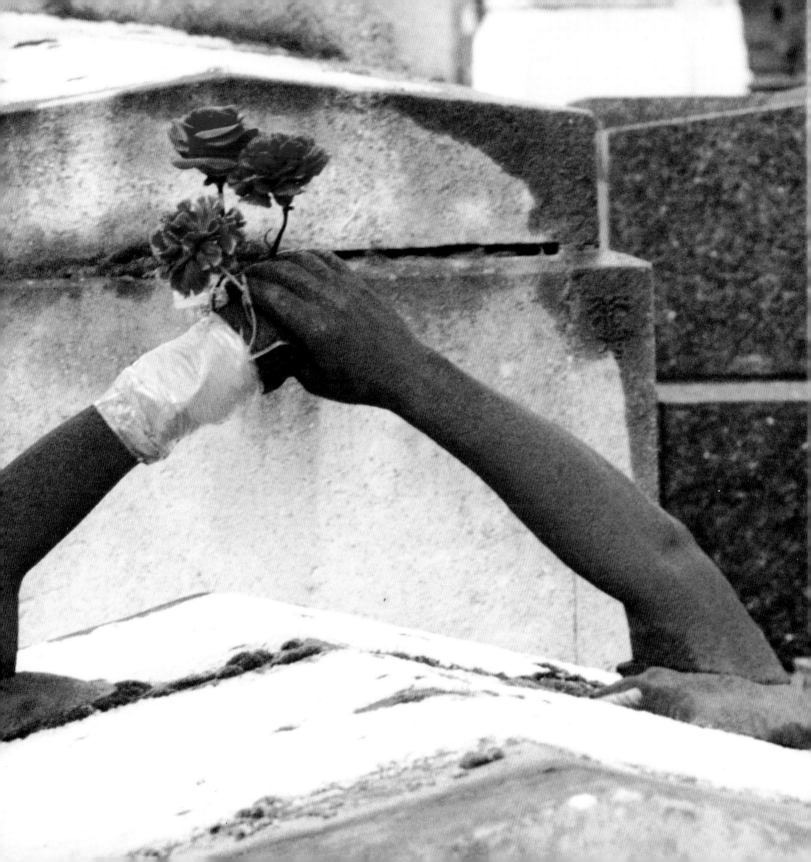

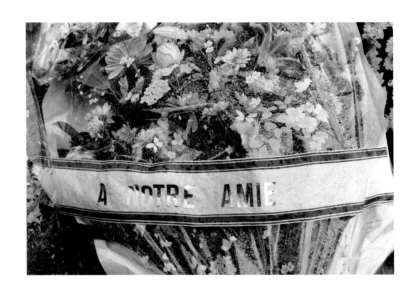

Père-Lachaise | *Père-Lachaise*

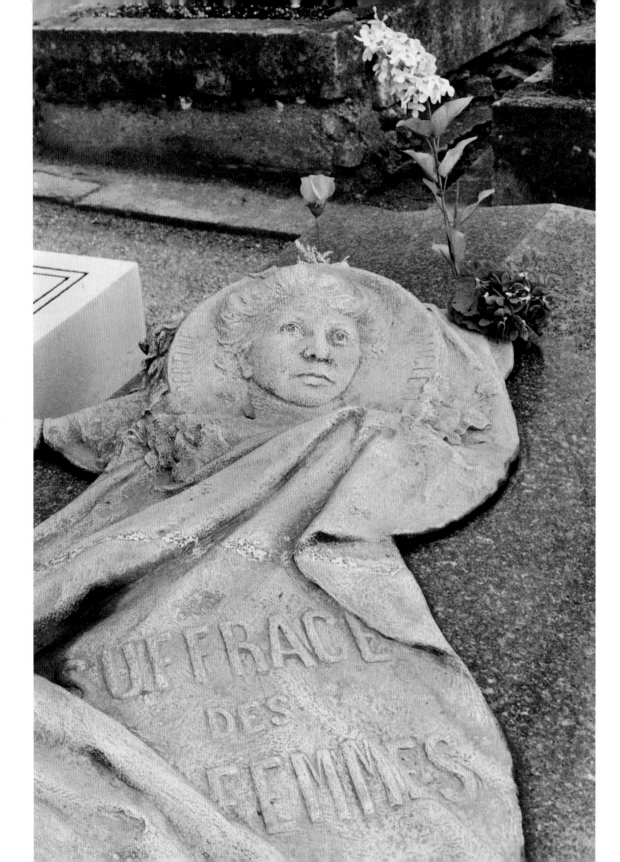

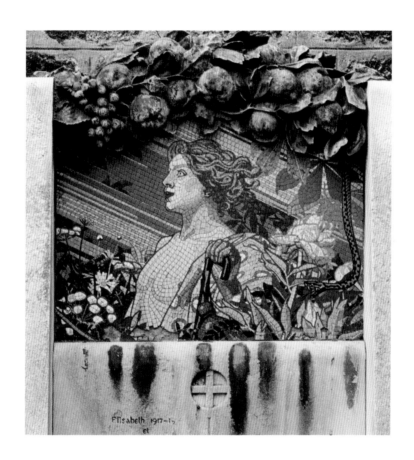

Père-Lachaise | Père-Lachaise

Père-Lachaise

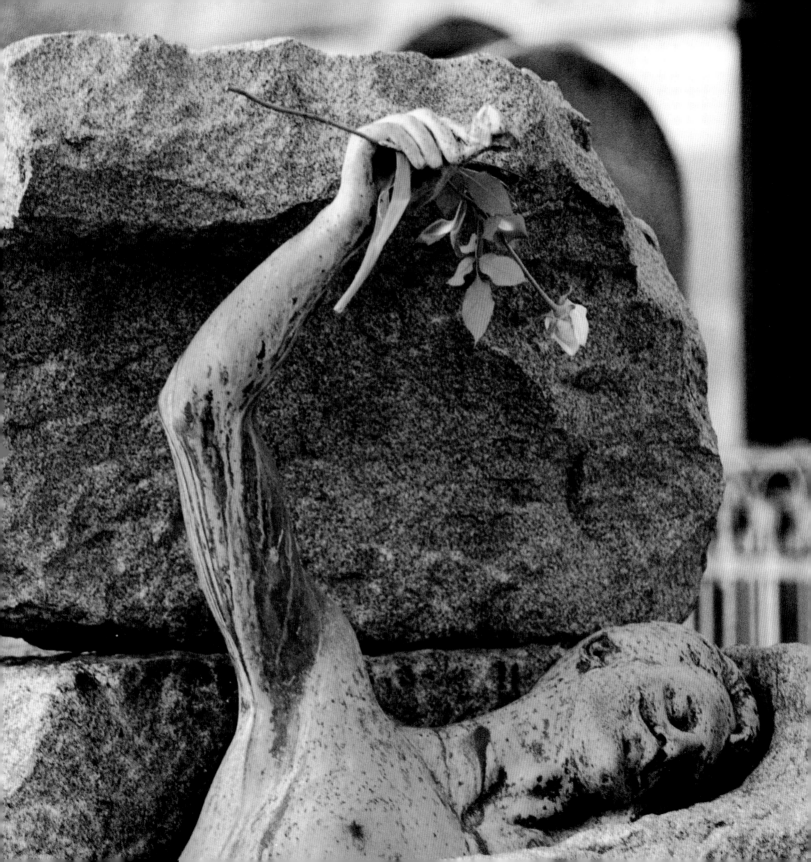

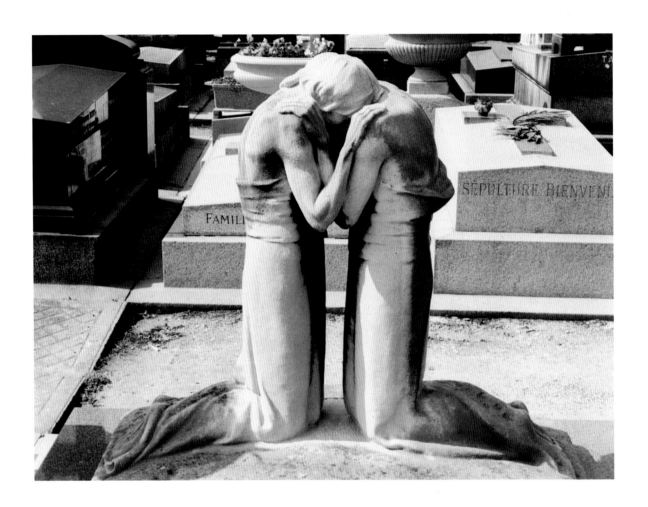

Père-Lachaise | *Père-Lachaise*

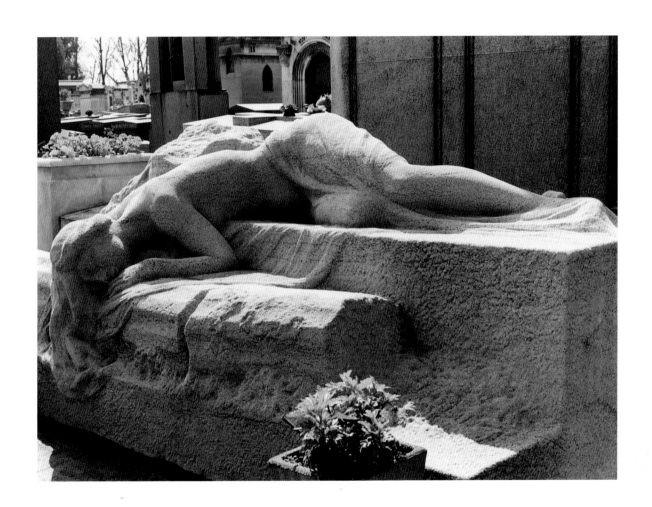

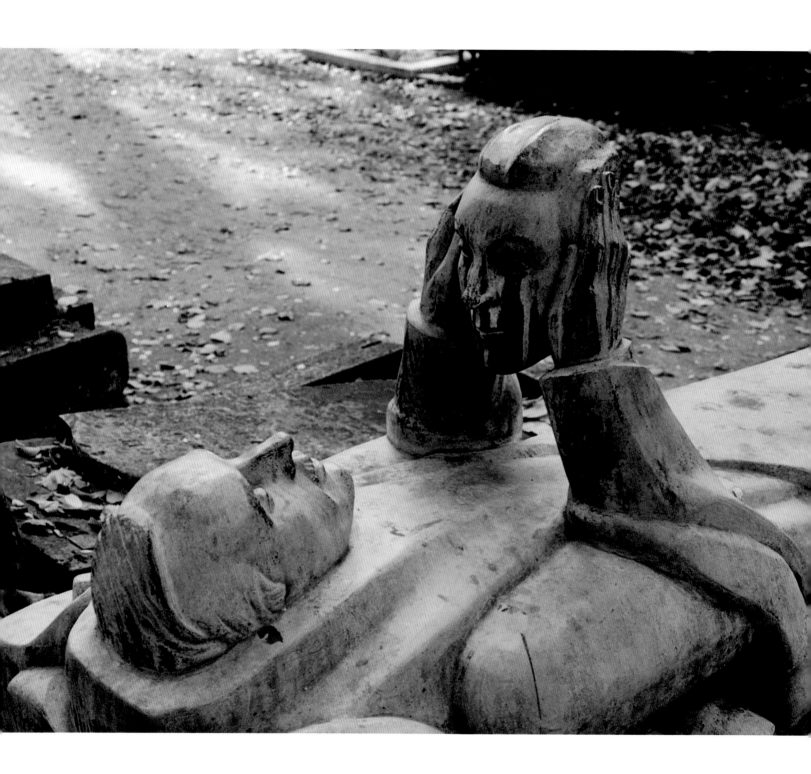

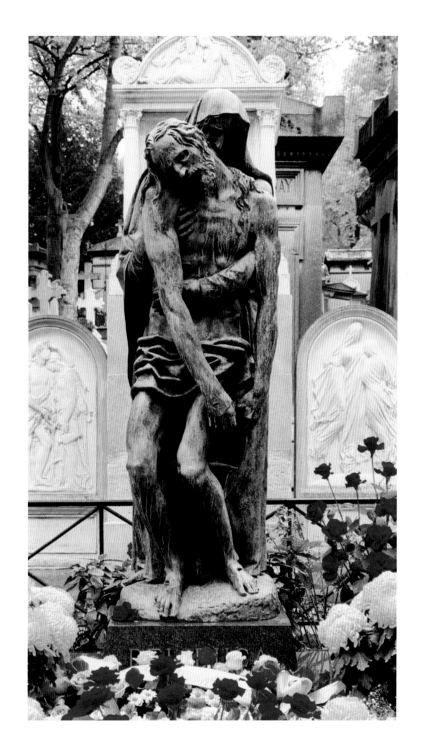

Père-Lachaise | Père-Lachaise

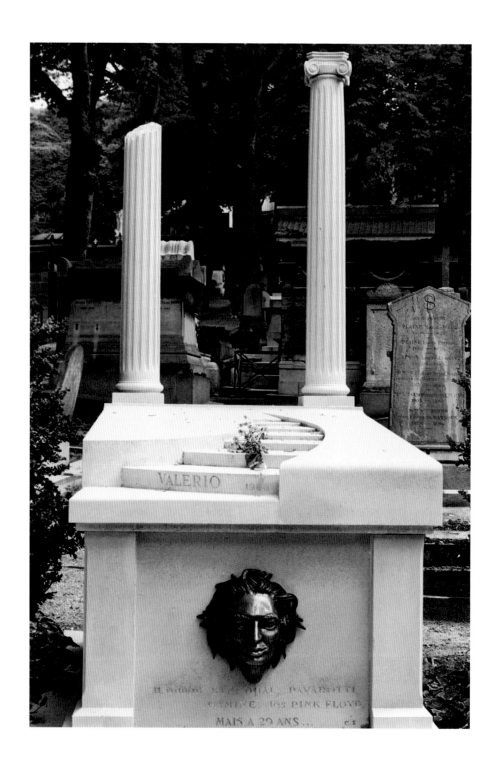

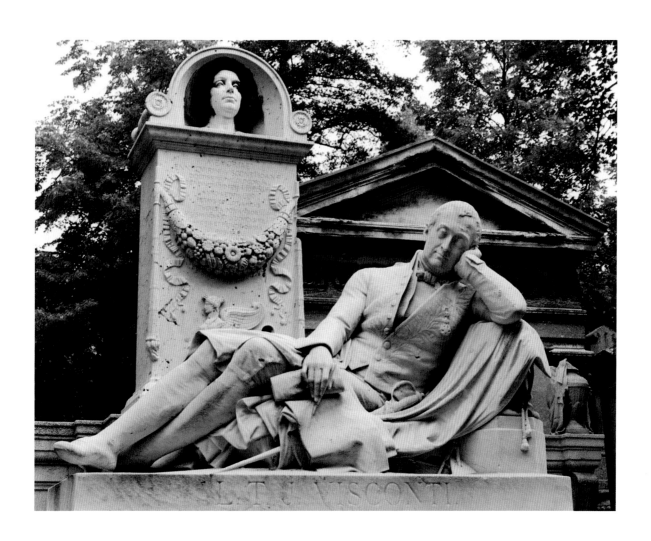

Père-Lachaise \ Père-Lachaise

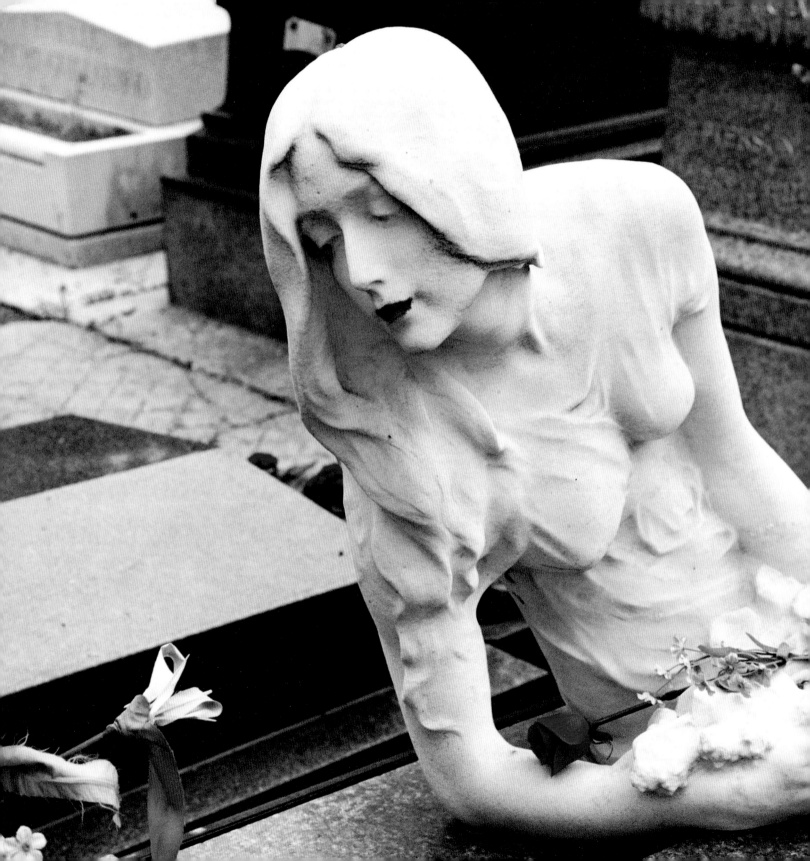

Père-Lachaise

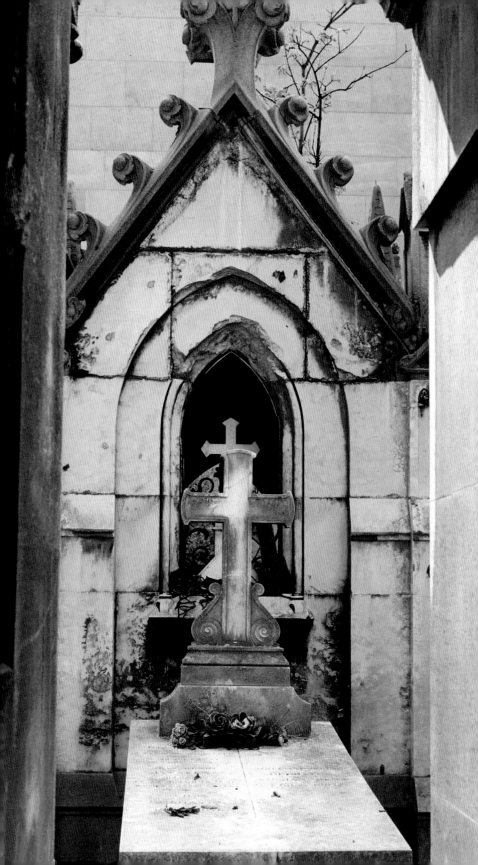

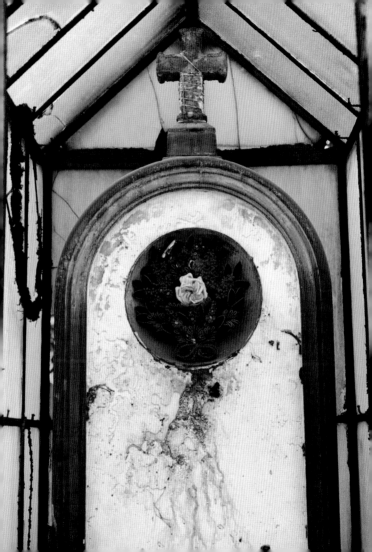

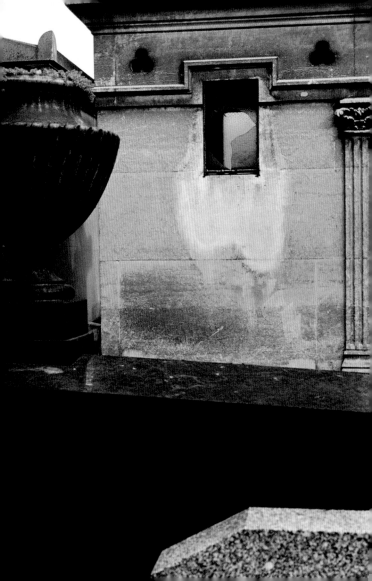

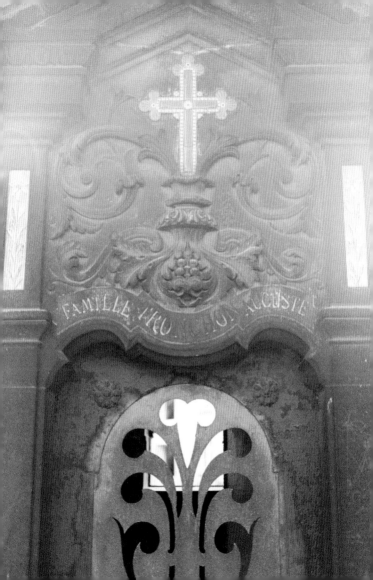

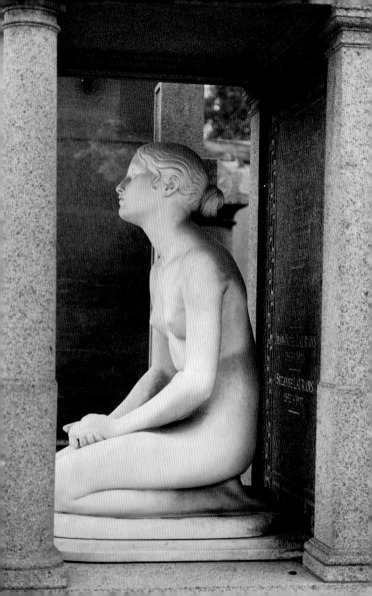

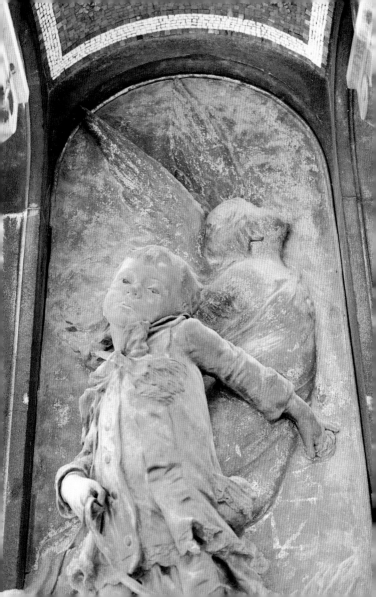

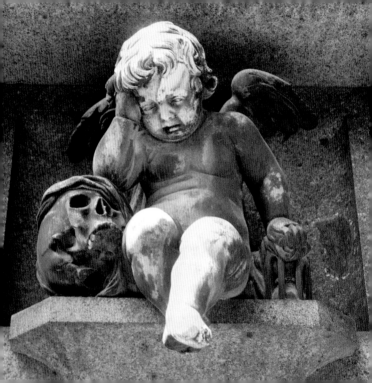

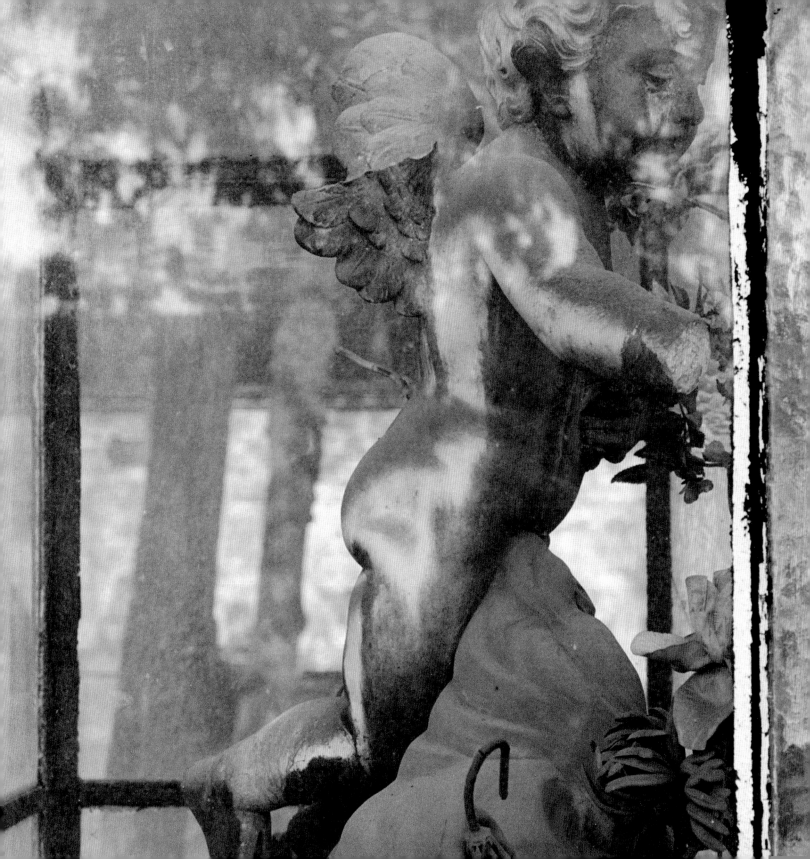

1826 –

Mme Vve J. KU[...]
NéE MARIE SCHNE[...]
1827 – 1910

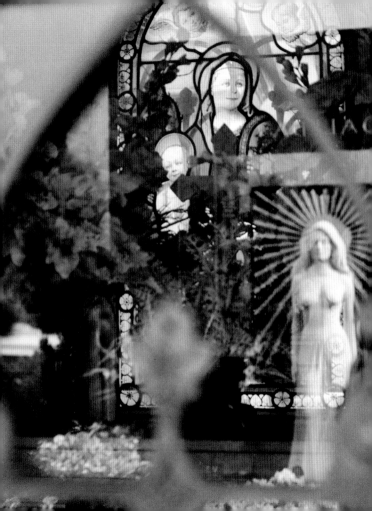

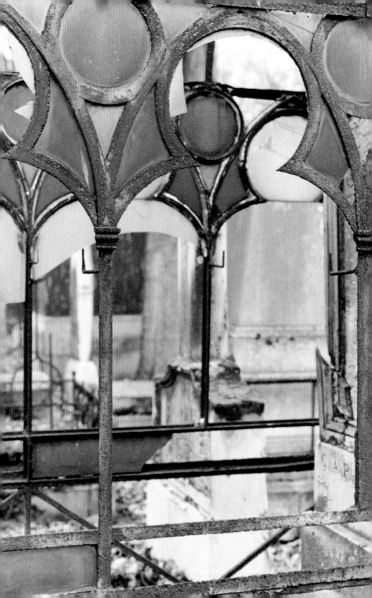

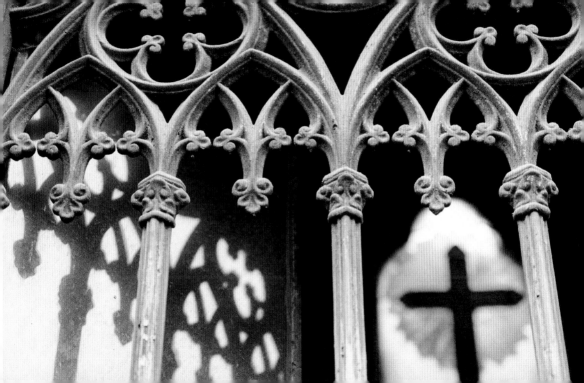

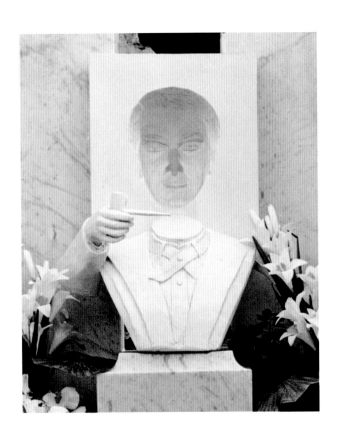 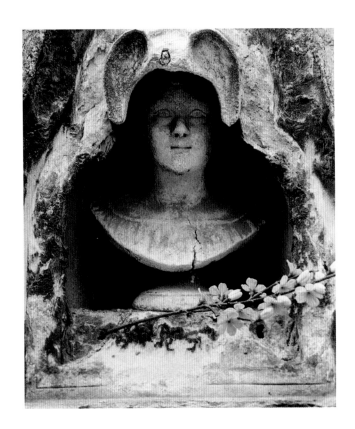

Montmartre | Montmartre | Montparnasse

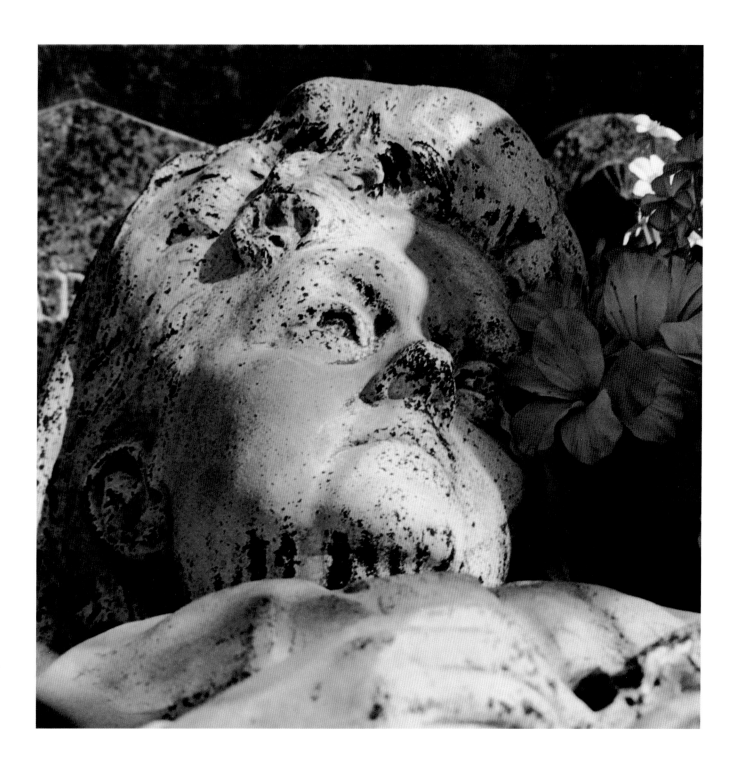

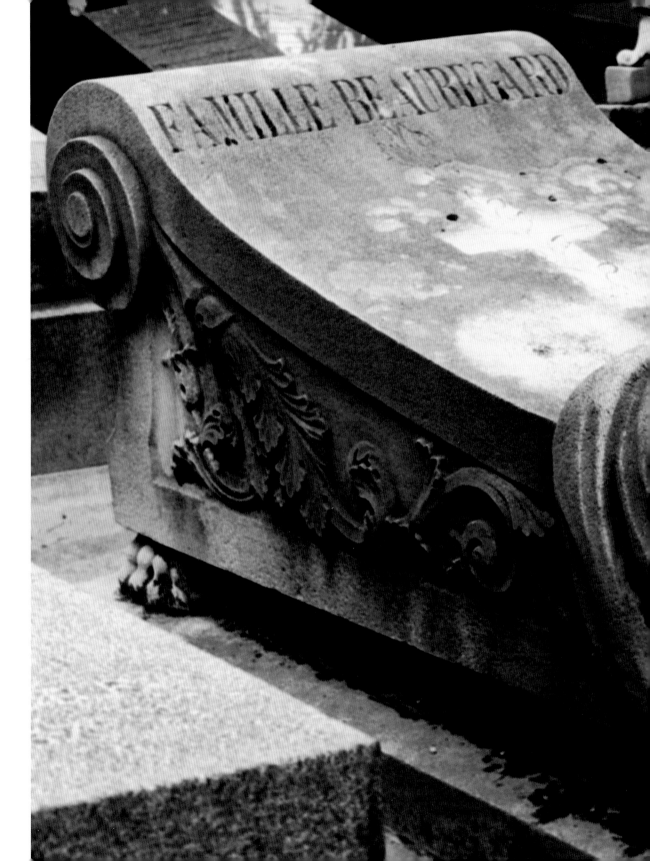

Passy

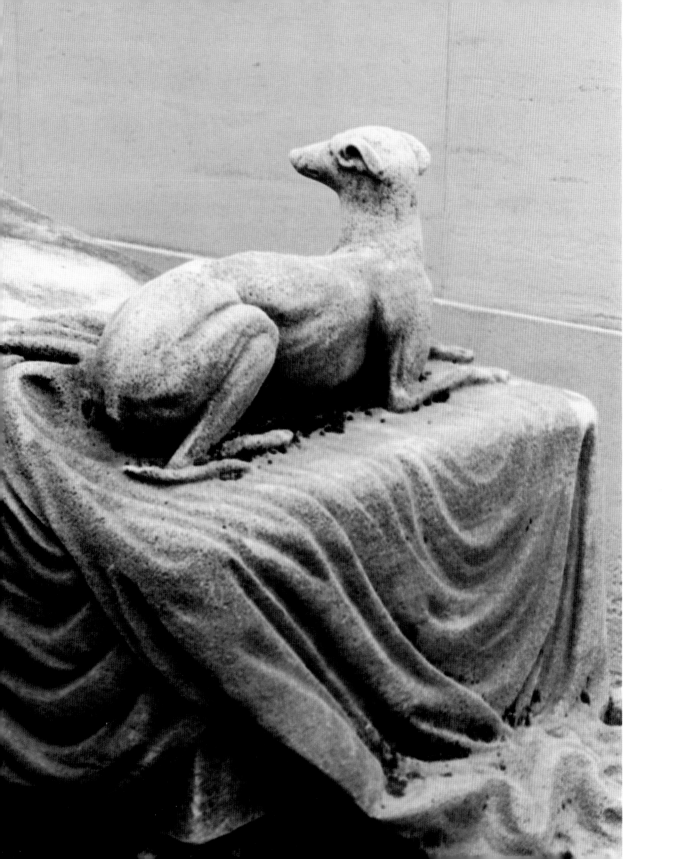

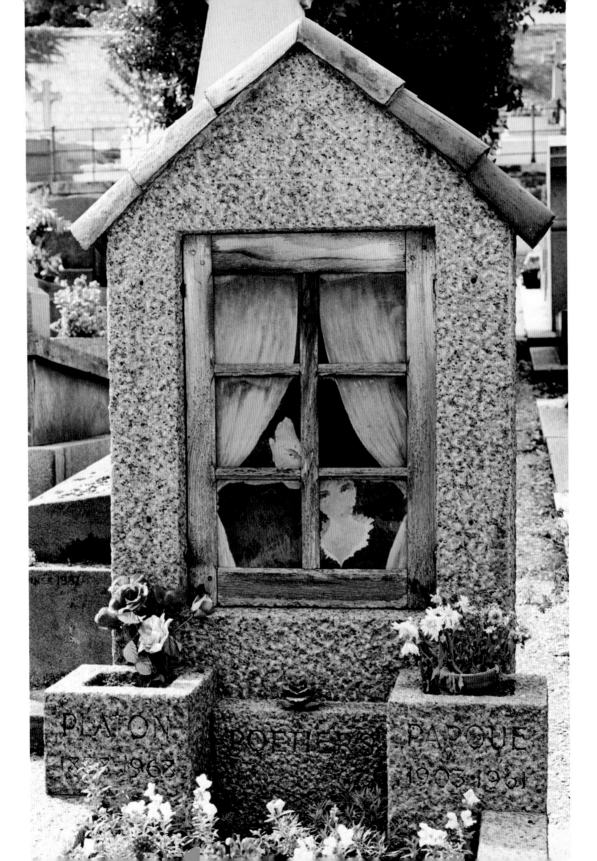

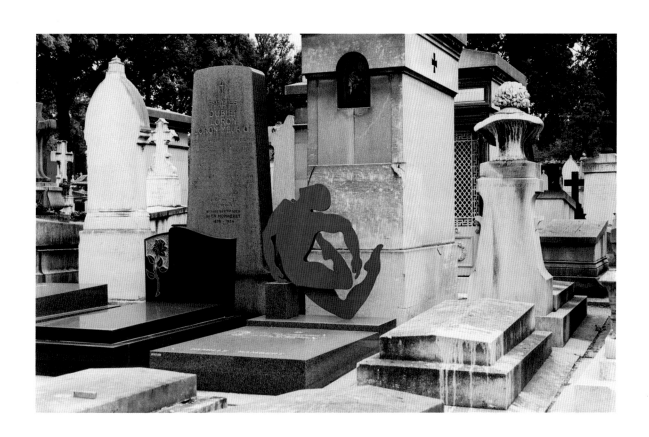

Saint-Vincent | *Montparnasse*

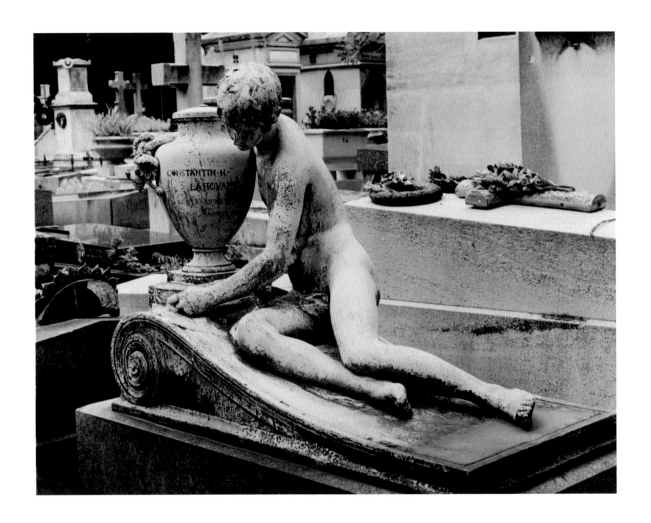

Père-Lachaise \ Passy

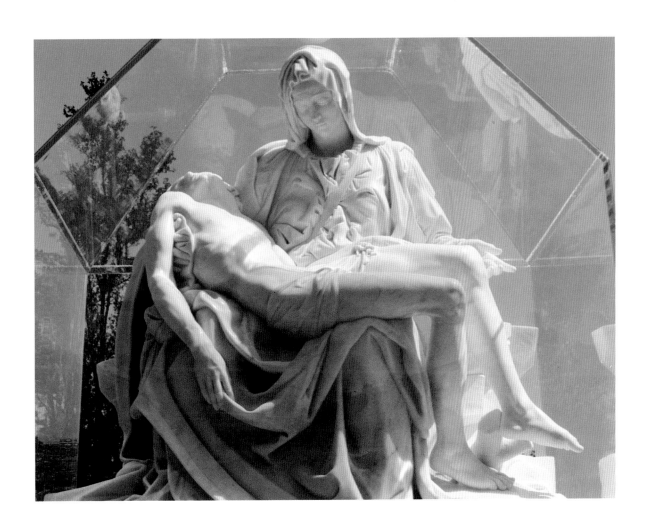

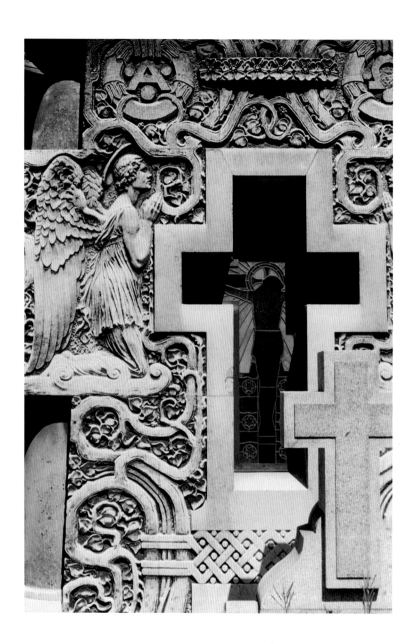

Passy \ *Père-Lachaise*

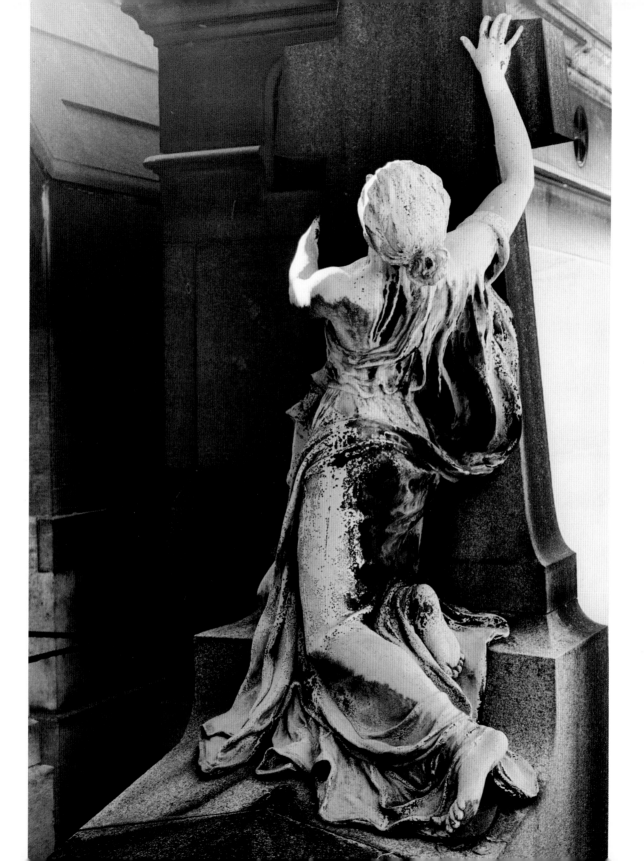

FRANCE

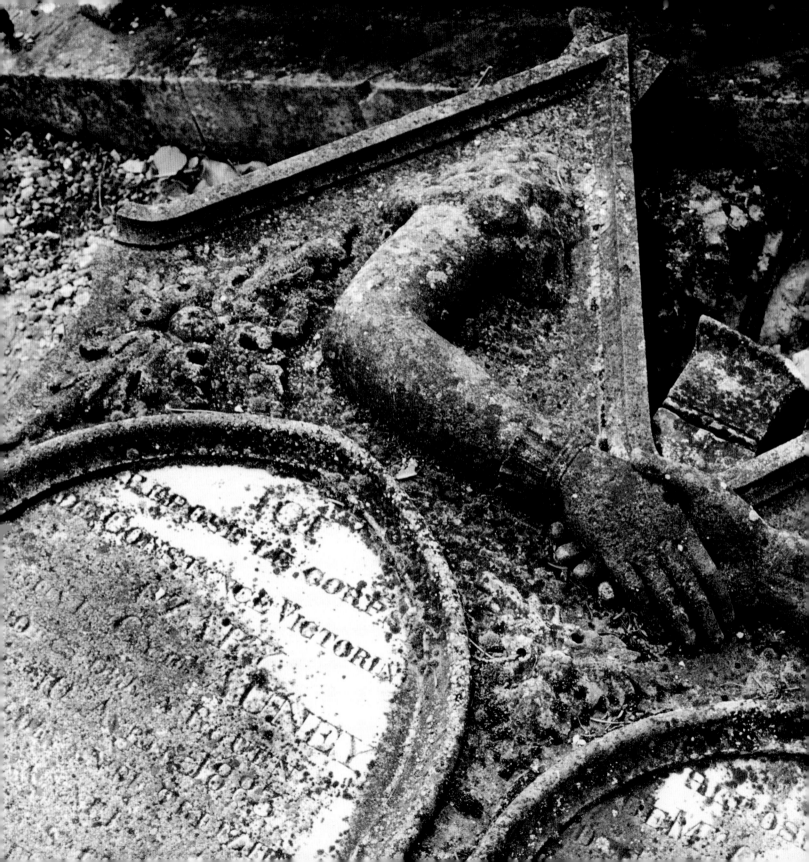

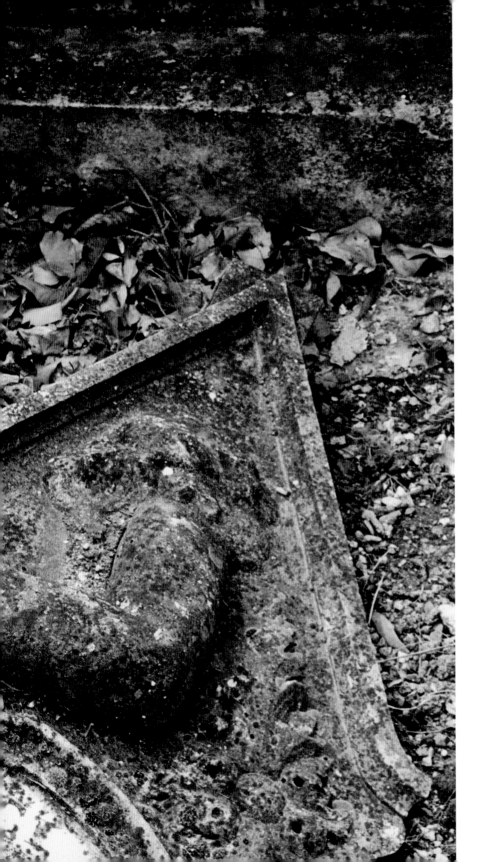

Rouen

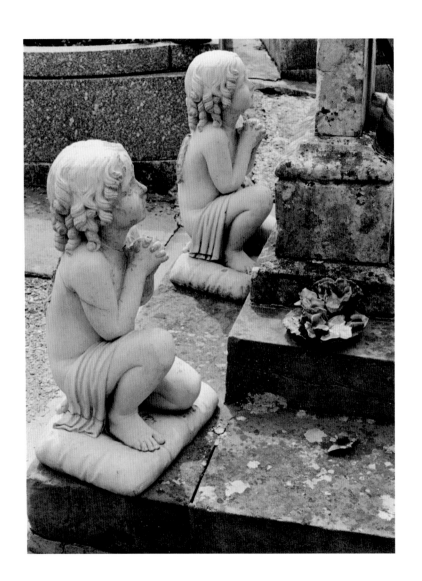

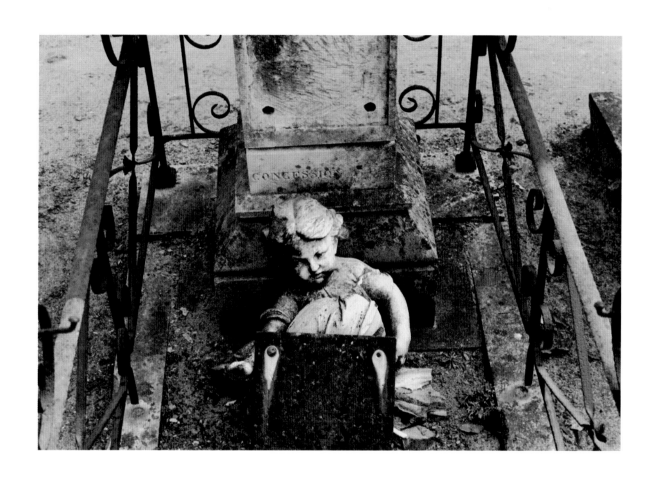

Toulouse | *Moret-sur-Loing*

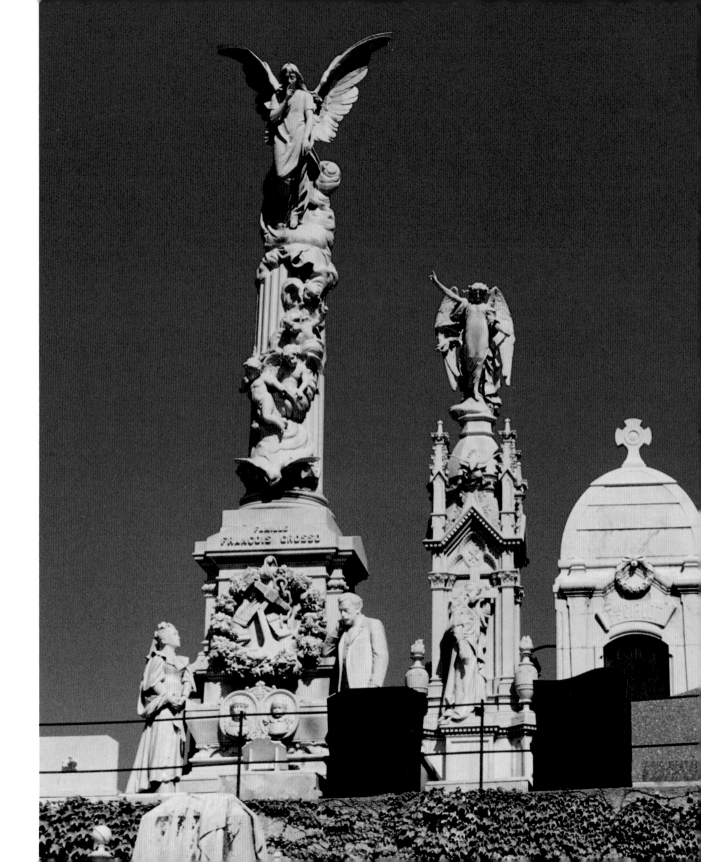

Nice

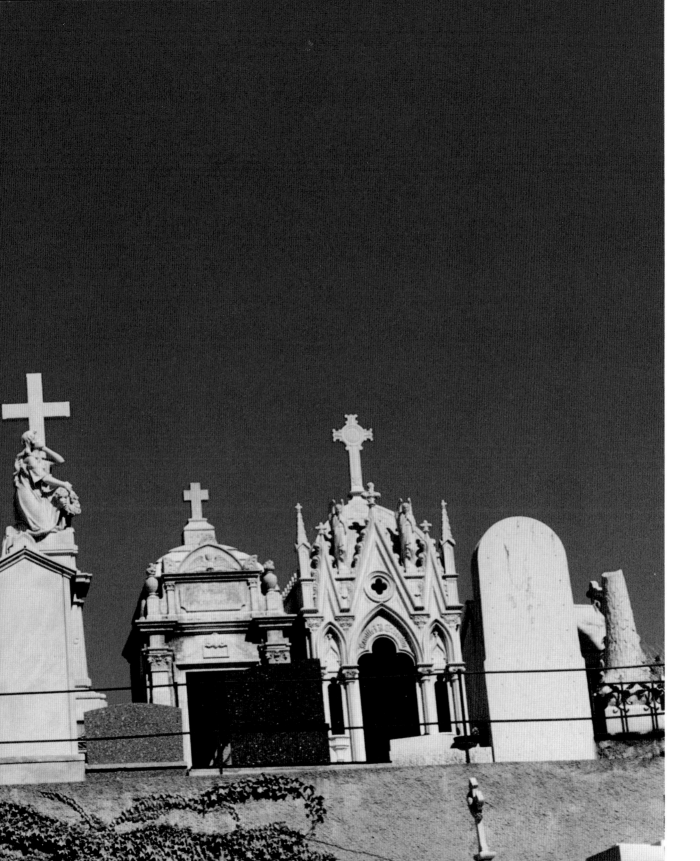

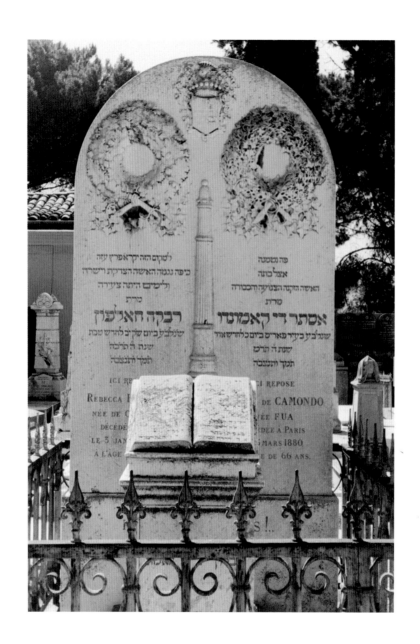

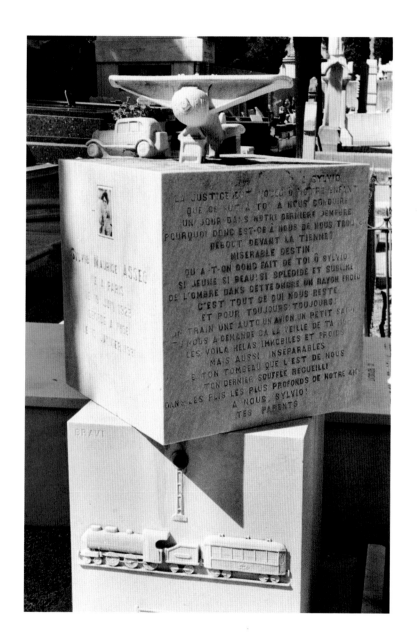

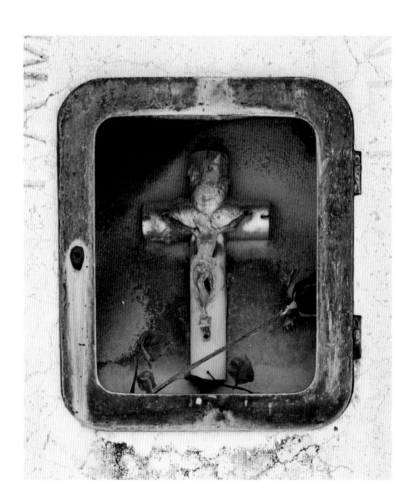

Aix-en-Provence | Crots

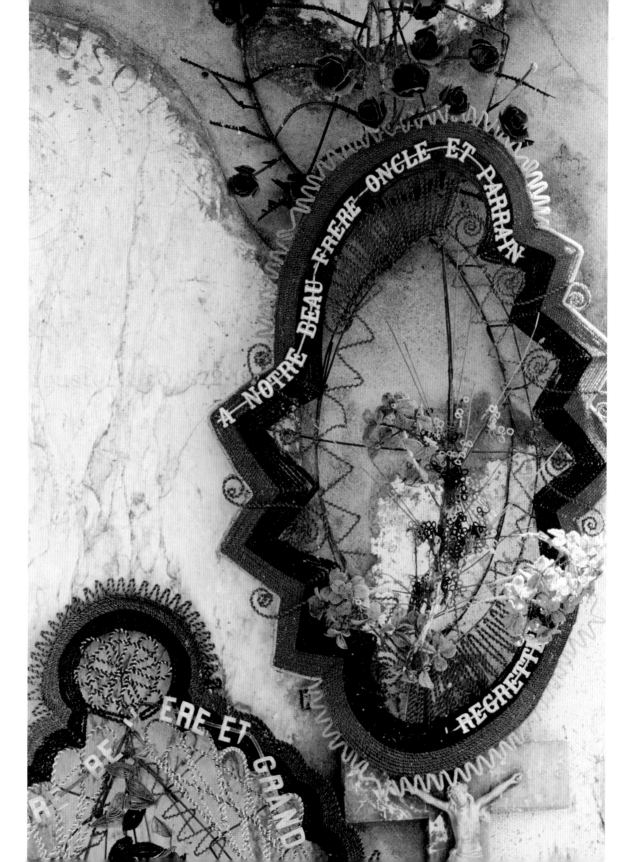

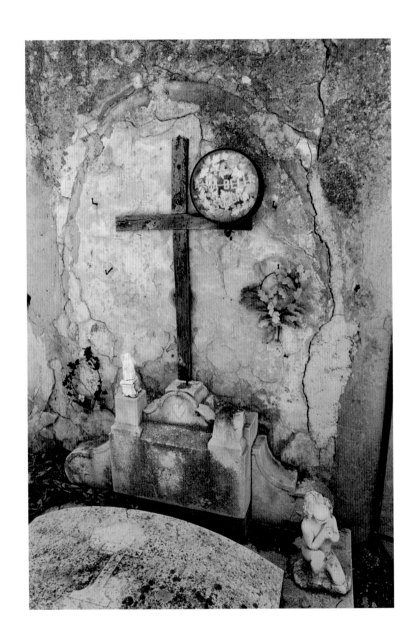

Aix-en-Provence | Aix-en-Provence

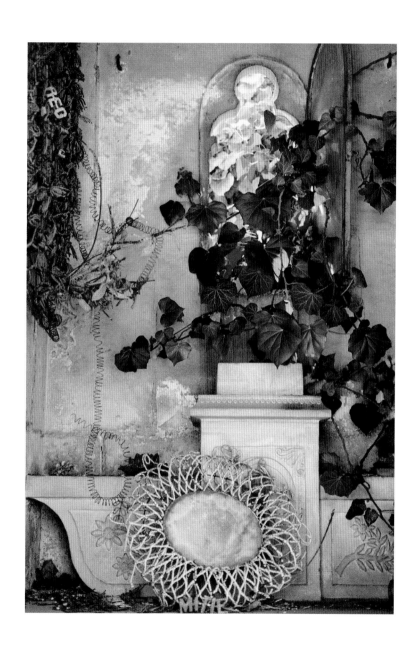

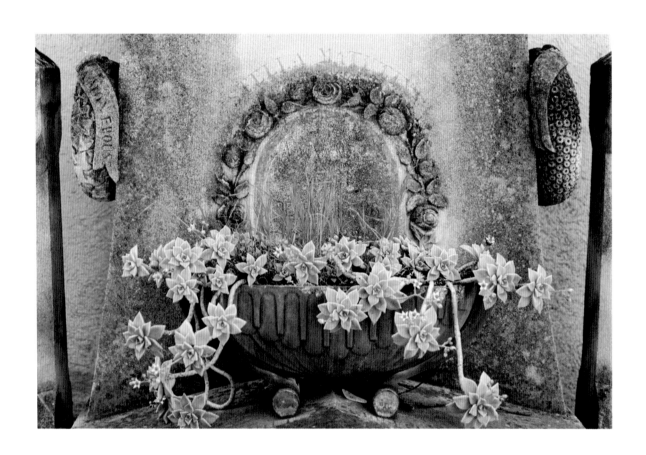

Aix-en-Provence | *Aix-en-Provence*

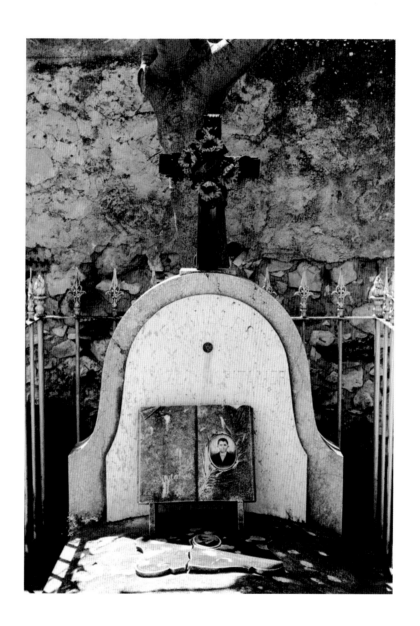

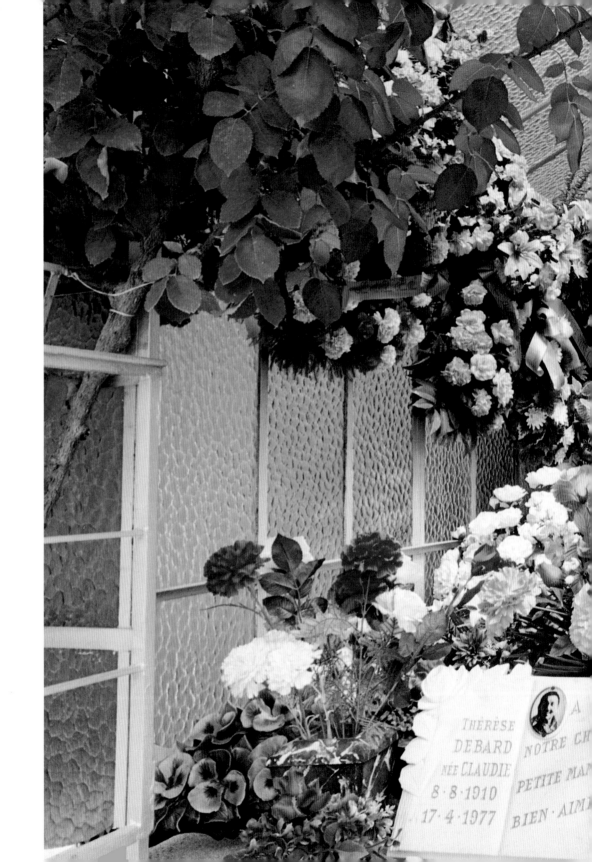

Montfermy

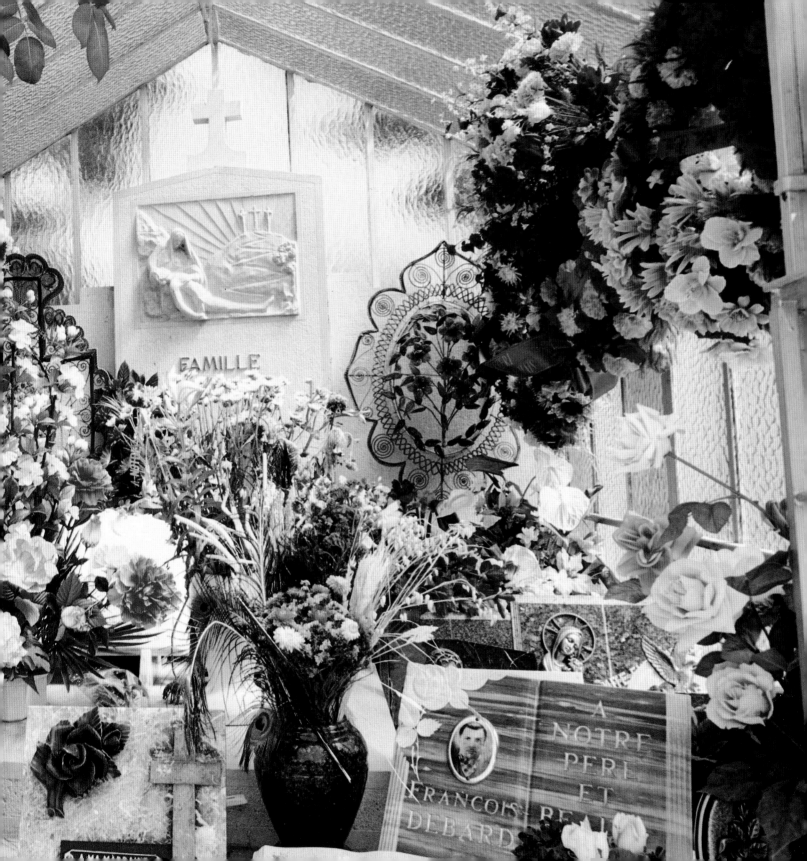

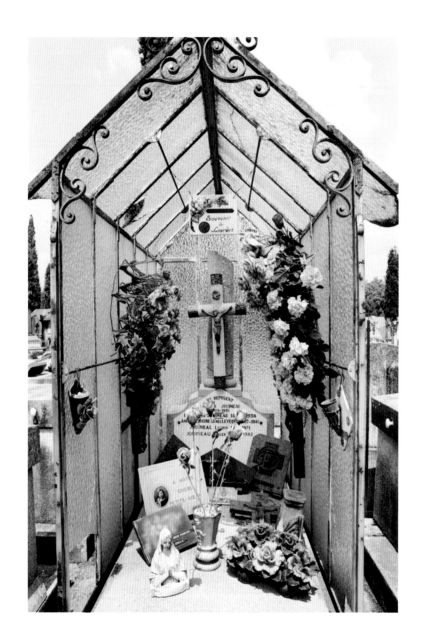

Albi | Montfermy

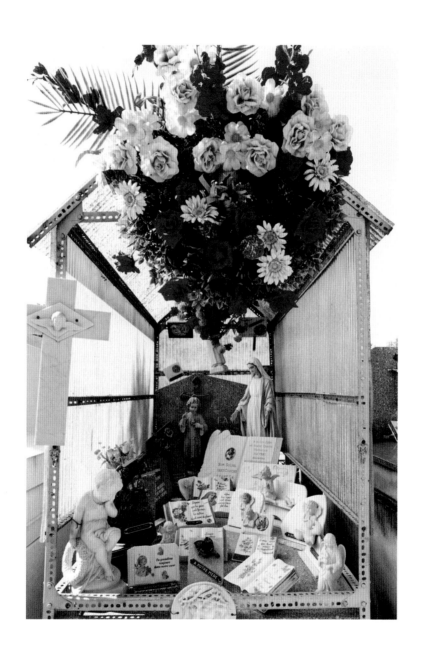

ENGLAND

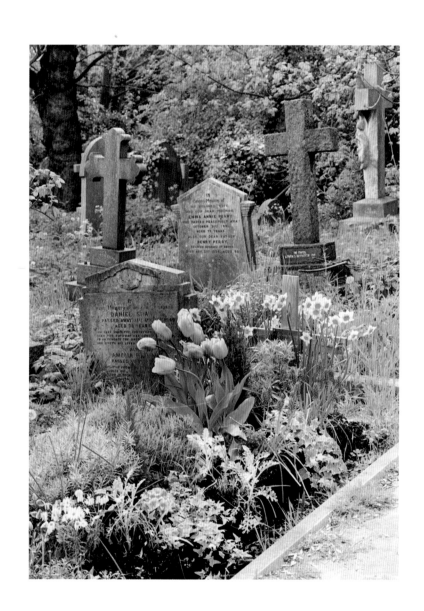

London, Highgate \ London, Brompton

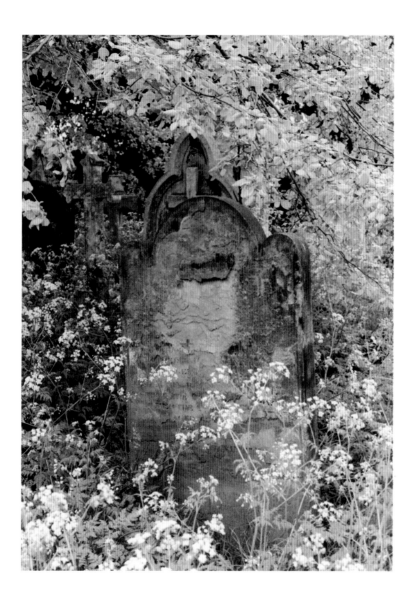

Overleaf, London, Highgate

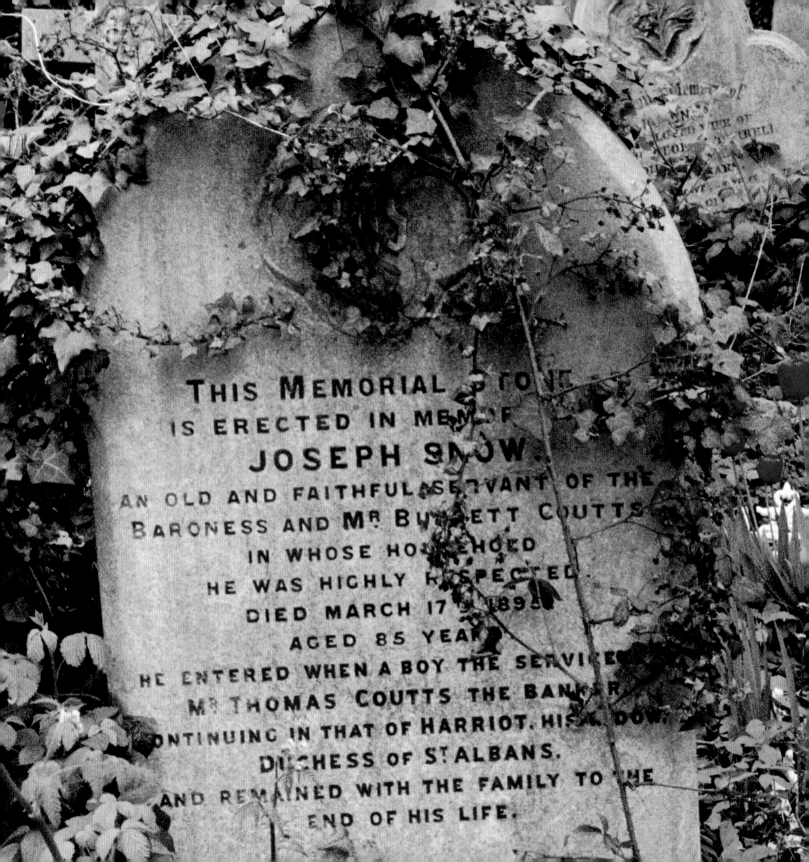

THIS MEMORIAL STONE
IS ERECTED IN MEMORY OF
JOSEPH SNOW.
AN OLD AND FAITHFUL SERVANT OF THE
BARONESS AND MR BURDETT COUTTS
IN WHOSE HOUSEHOLD
HE WAS HIGHLY RESPECTED.
DIED MARCH 17TH 1895
AGED 85 YEARS
HE ENTERED WHEN A BOY THE SERVICE
MR THOMAS COUTTS THE BANKER
CONTINUING IN THAT OF HARRIOT, HIS DOW
DUCHESS OF ST ALBANS,
AND REMAINED WITH THE FAMILY TO THE
END OF HIS LIFE.

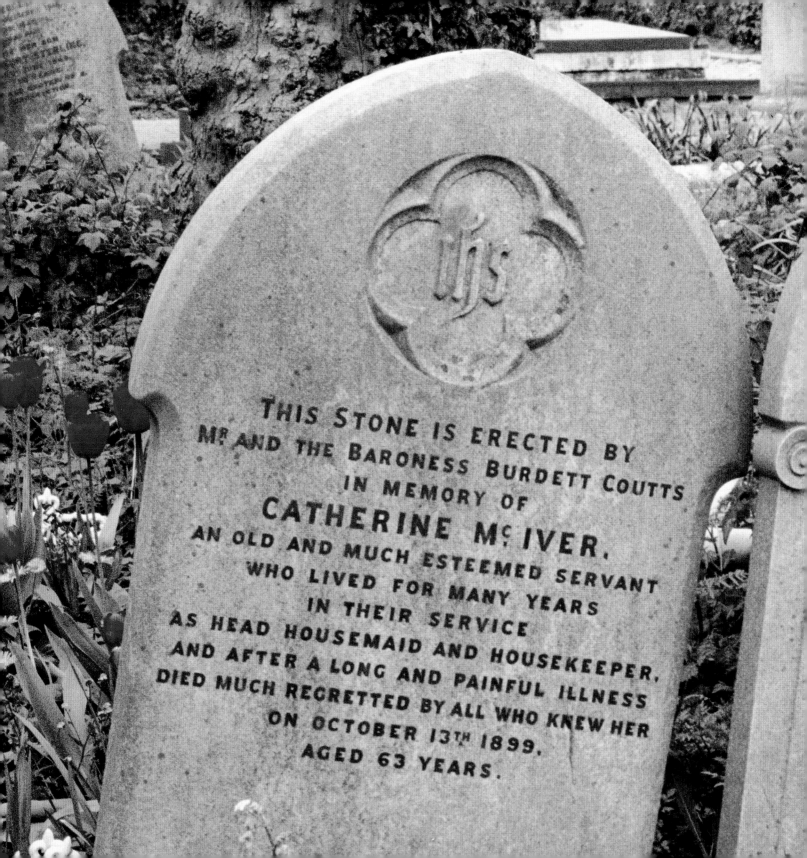

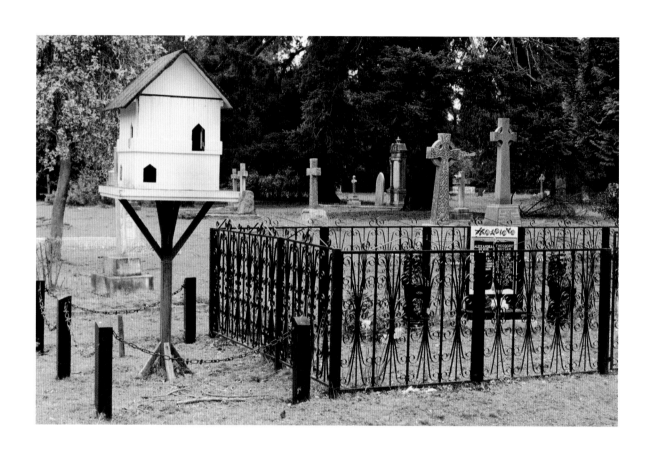

Woking | London, Chiswick

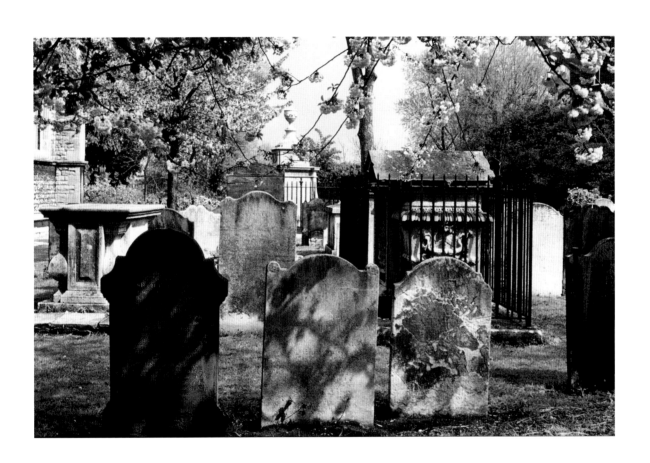

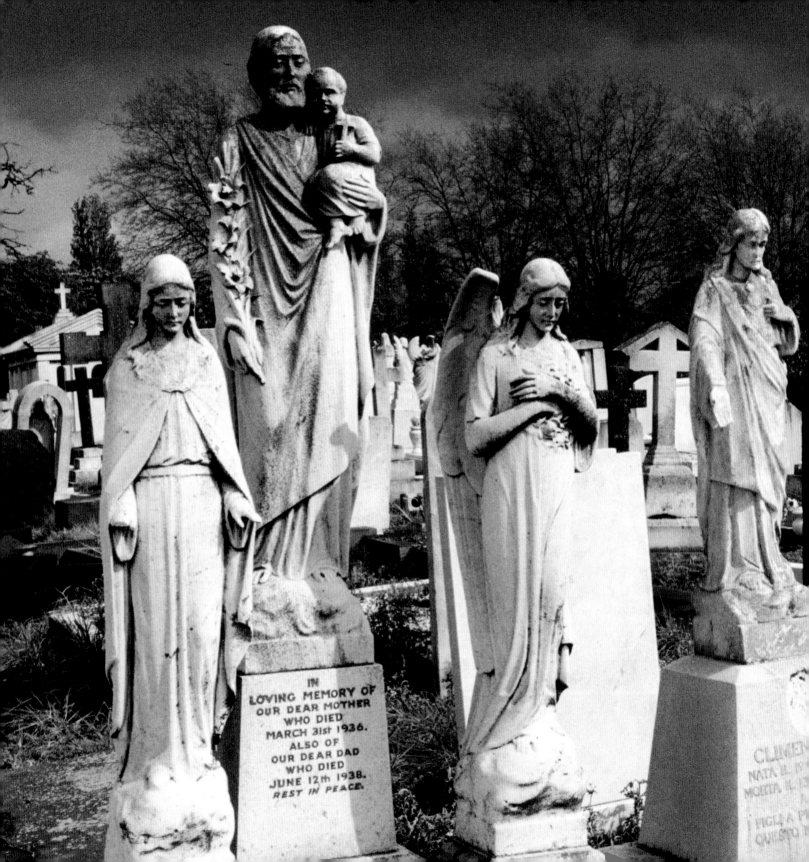

IN
LOVING MEMORY OF
OUR DEAR MOTHER
WHO DIED
MARCH 31st 1936.
ALSO OF
OUR DEAR DAD
WHO DIED
JUNE 12th 1938.
REST IN PEACE.

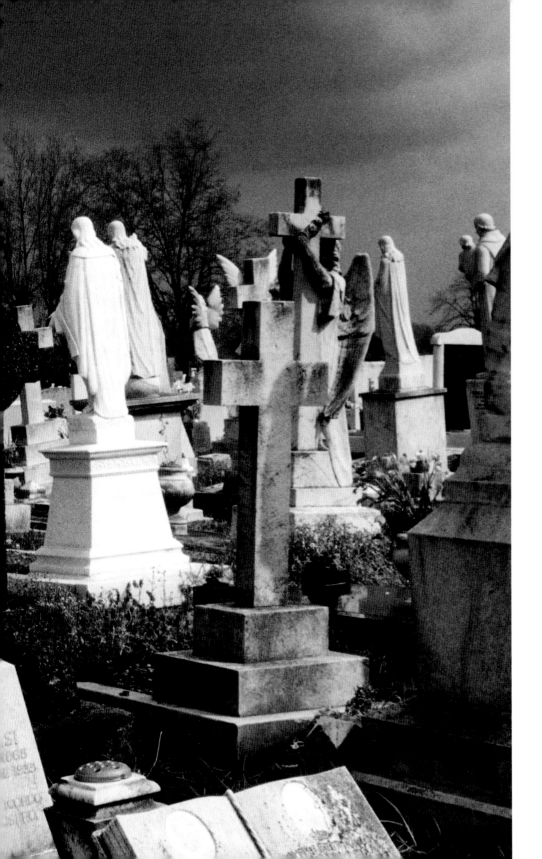

London, Saint Mary's

PRAGUE

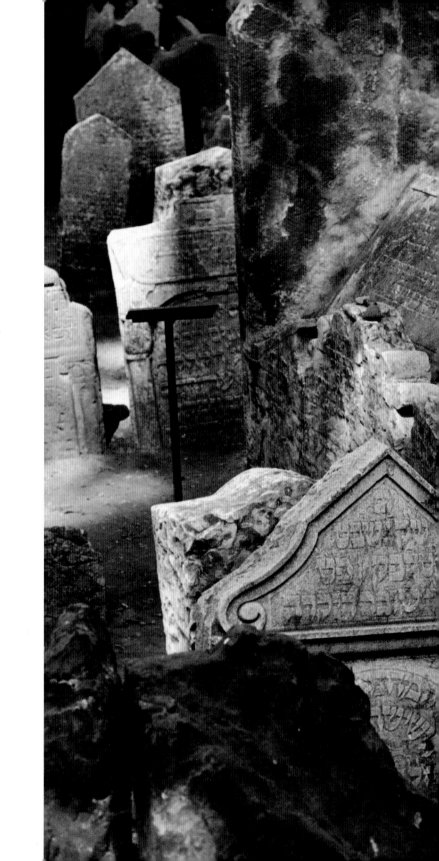

Prague, Jewish Cemetery

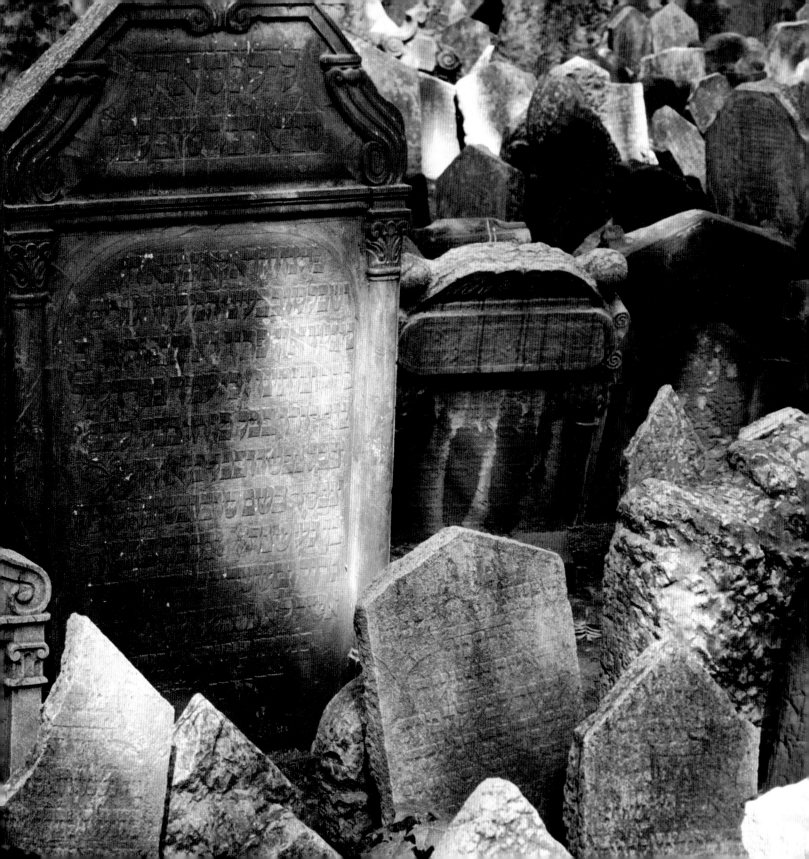

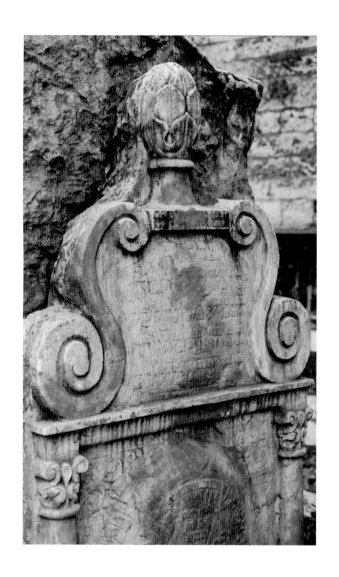

Prague, Jewish Cemetery | Prague, Jewish Cemetery

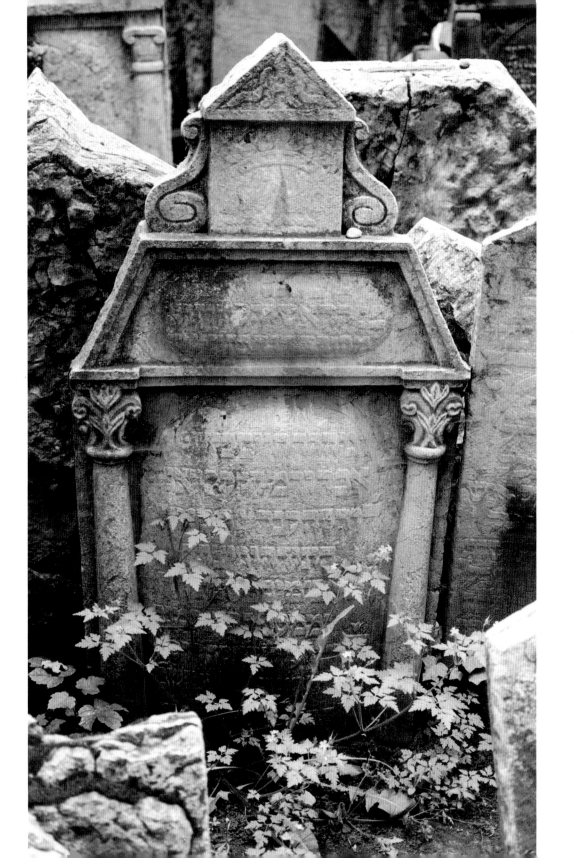

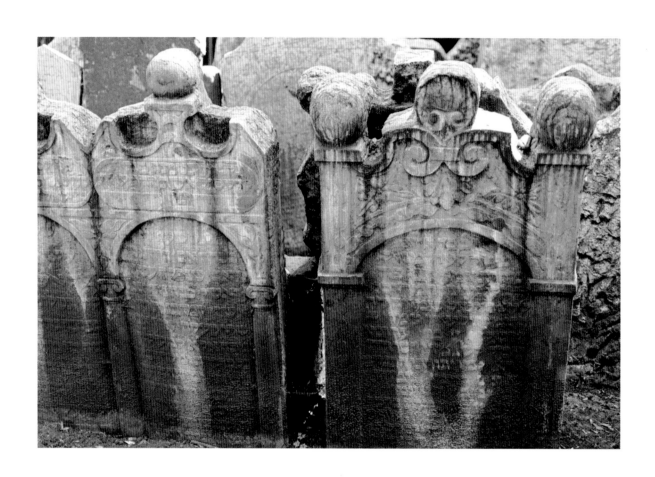

Prague, Jewish Cemetery \ Prague, Jewish Cemetery

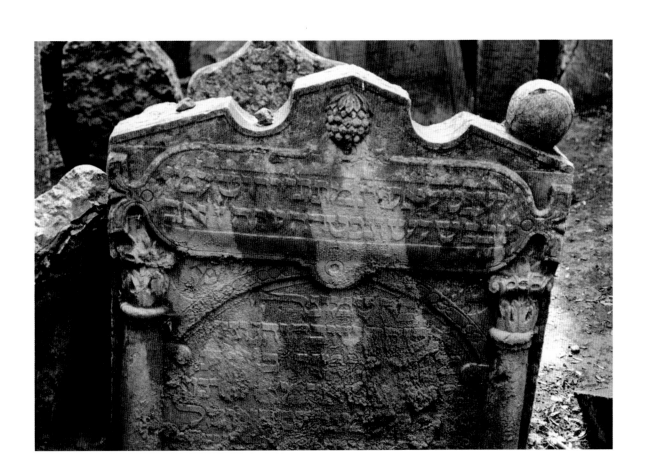

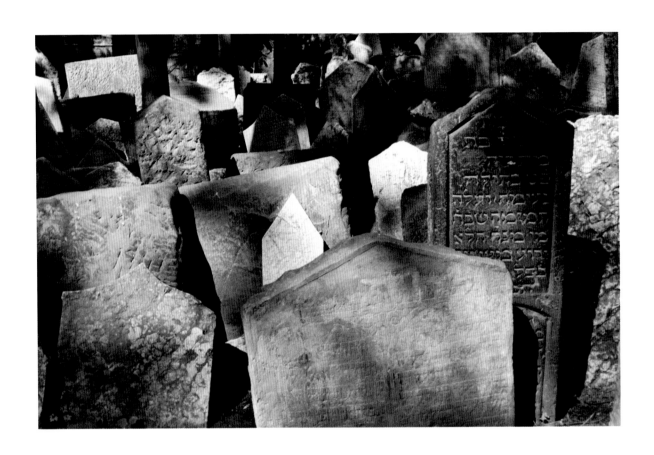

Prague, Jewish Cemetery | Prague, Jewish Cemetery

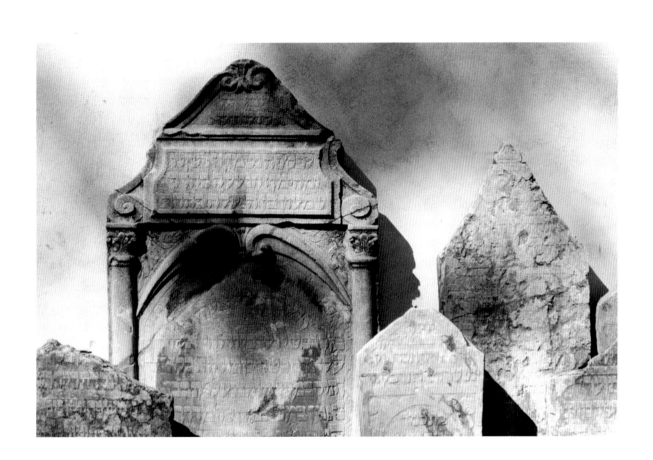

SPAIN
&
PORTUGAL

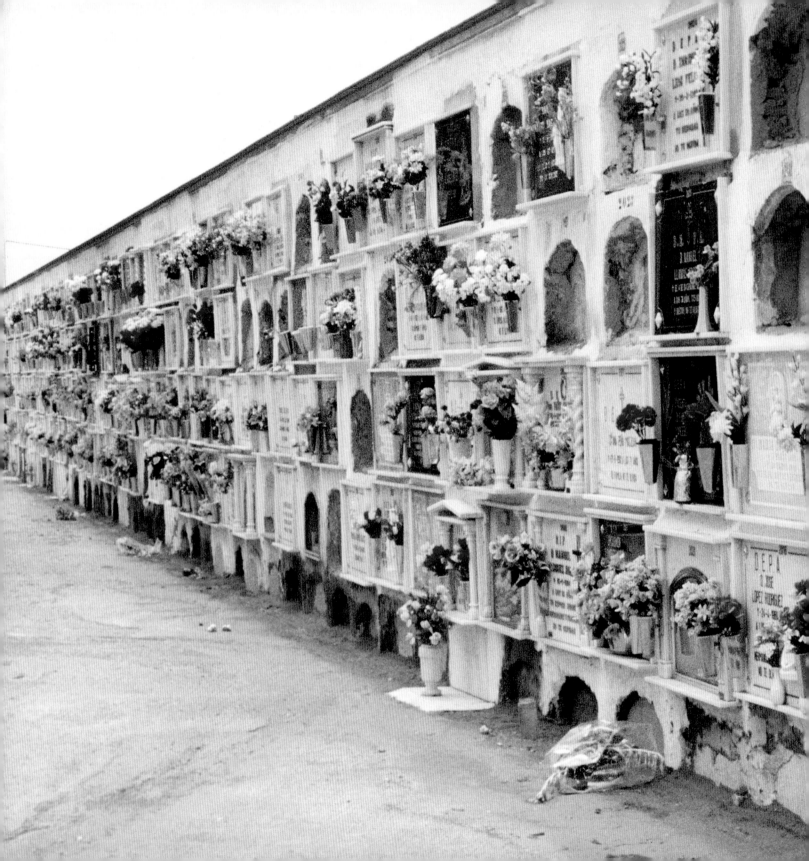

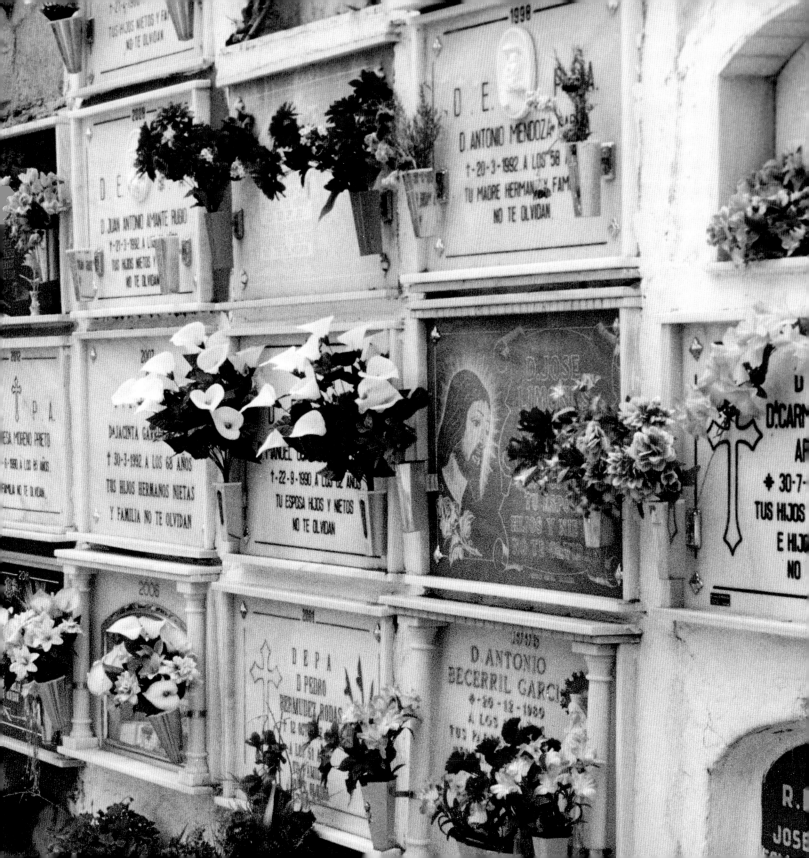

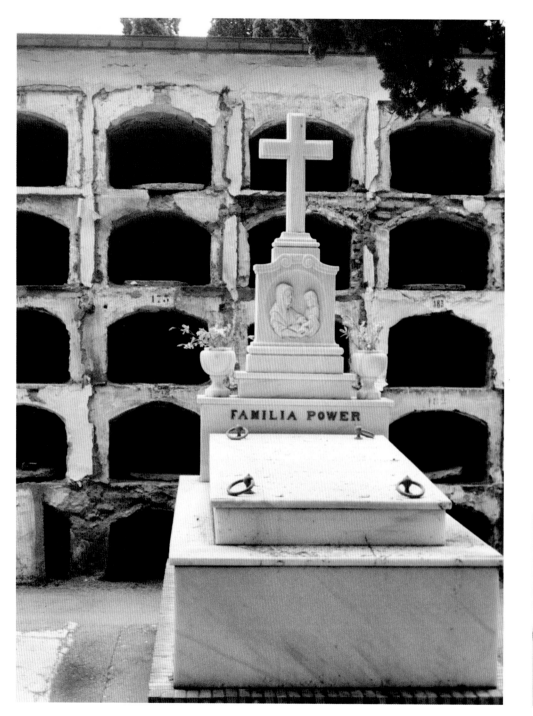
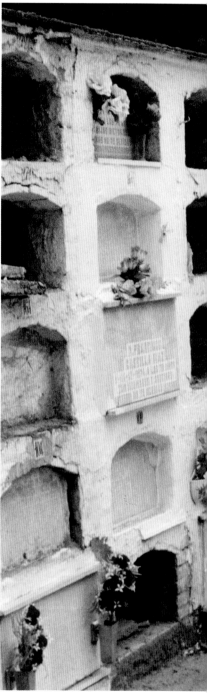

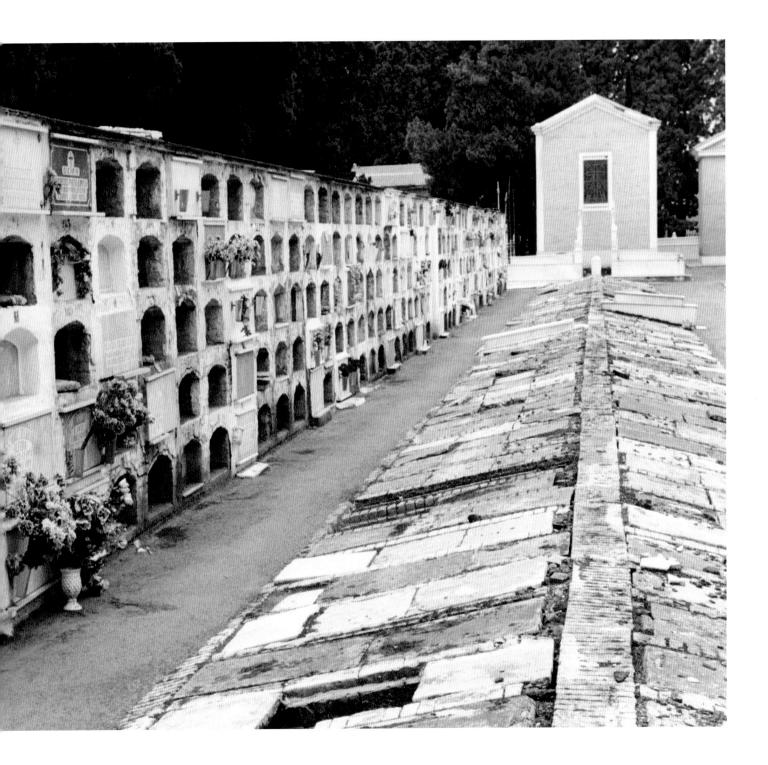

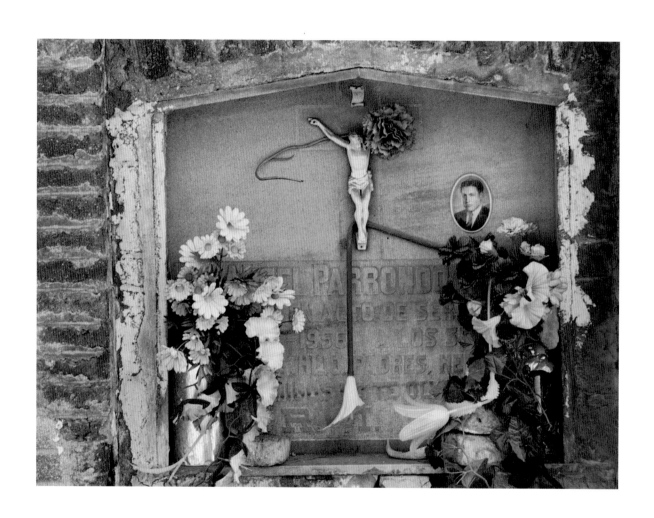

Previous pages, Seville | Madrid, Almudena | Madrid, Almudena

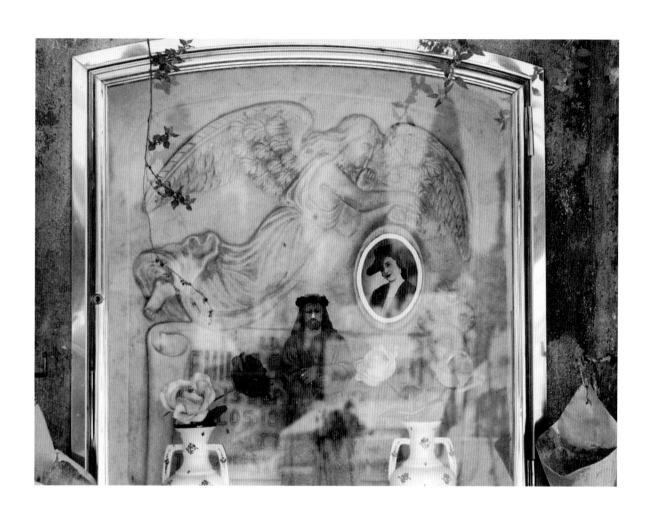

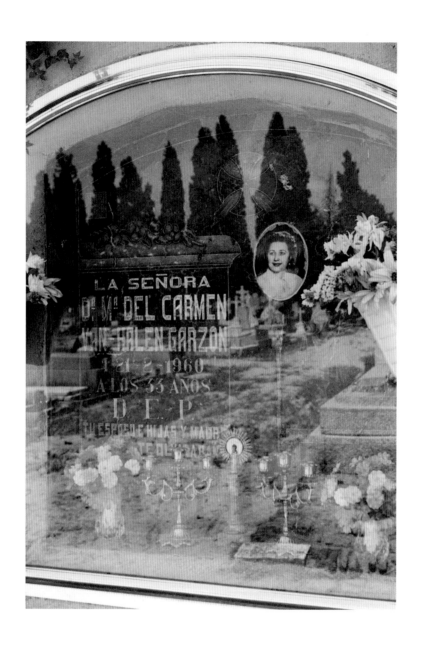

Madrid, Almudena \ Salamanca

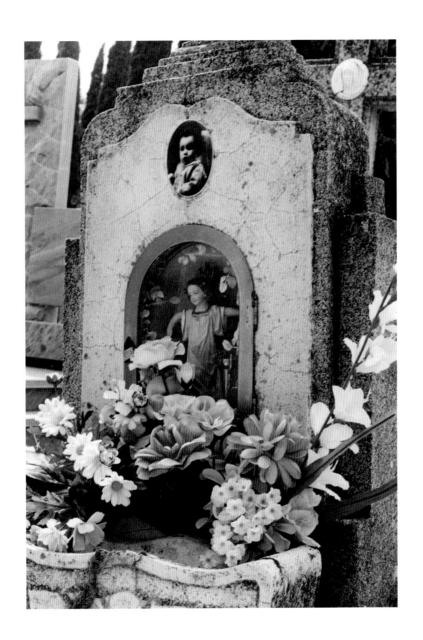

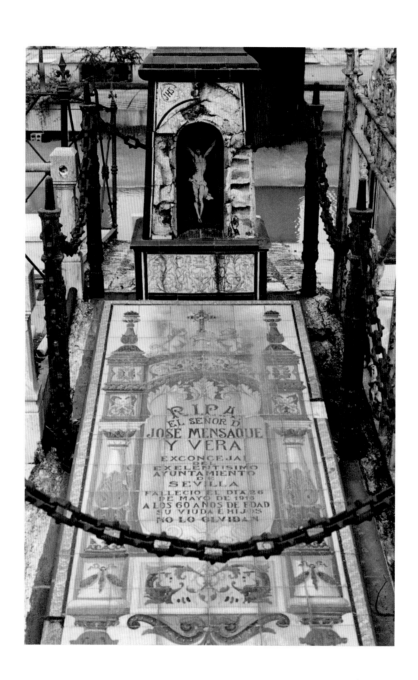

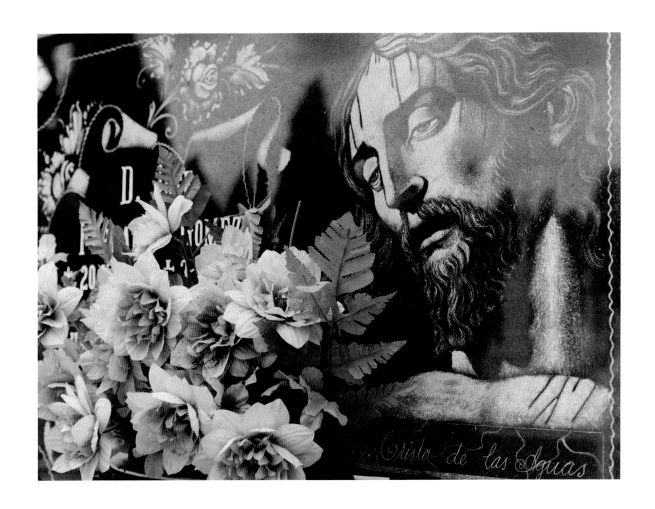

Seville | Seville

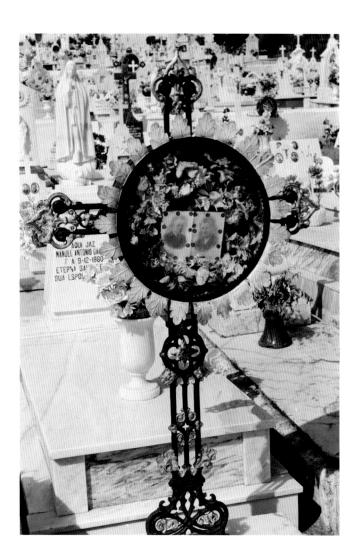 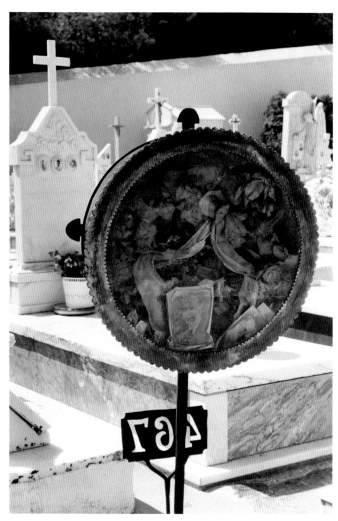

Redondo, Portugal | Vila Viçosa, Portugal

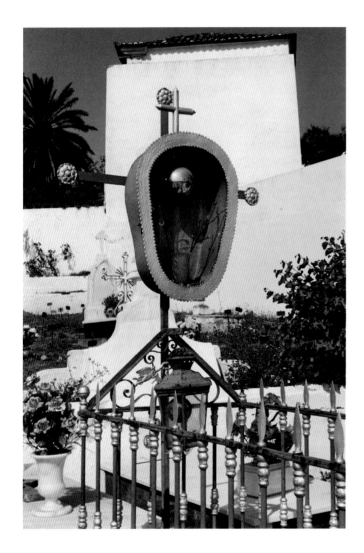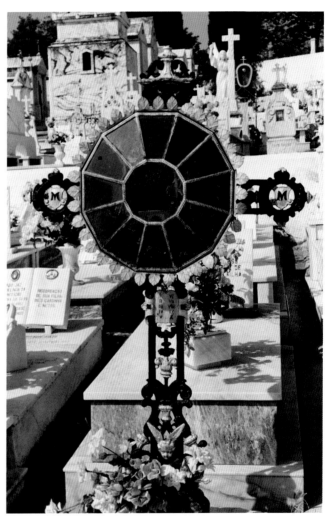

Redondo, Portugal \ Redondo, Portugal

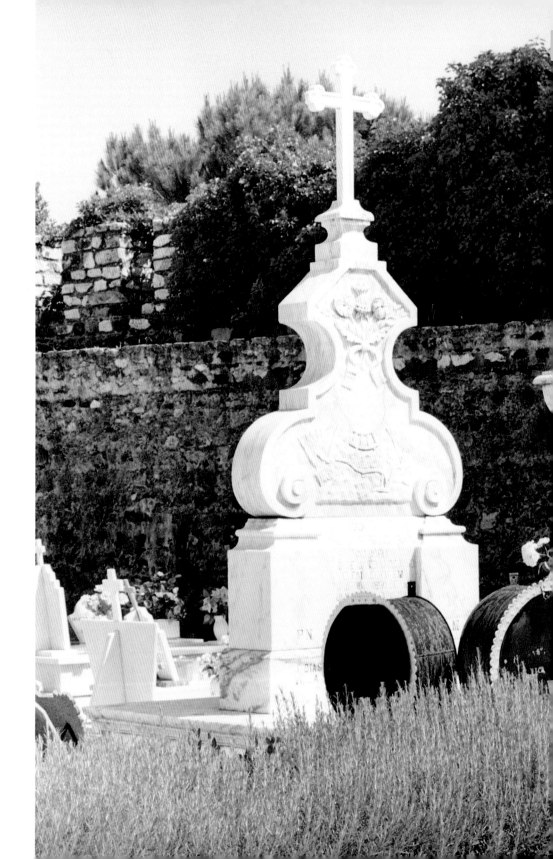

Vila Viçosa, Portugal

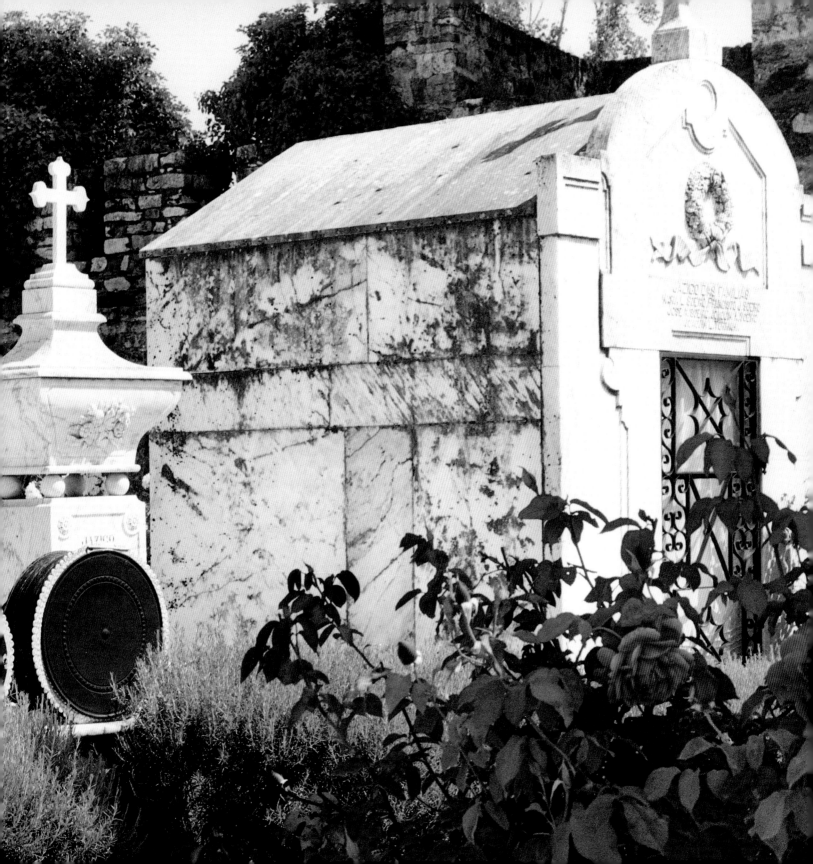

ITALY

Milan, Cimitero Monumentale

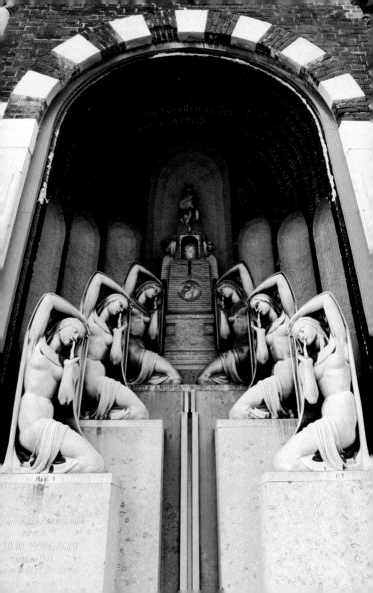

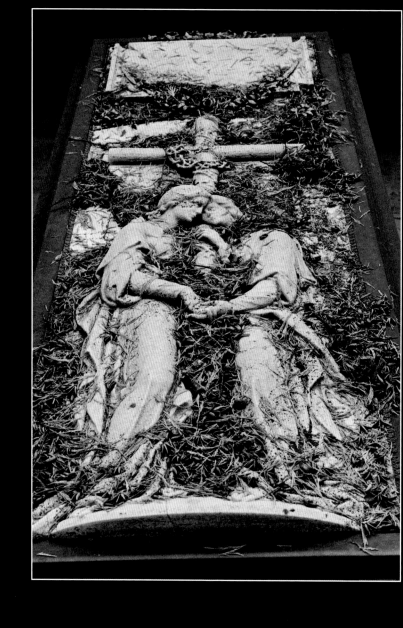

Cimitero Monumentale | Milan, Cimitero Monumentale

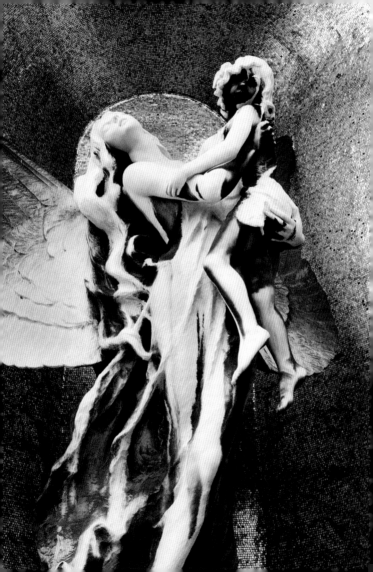

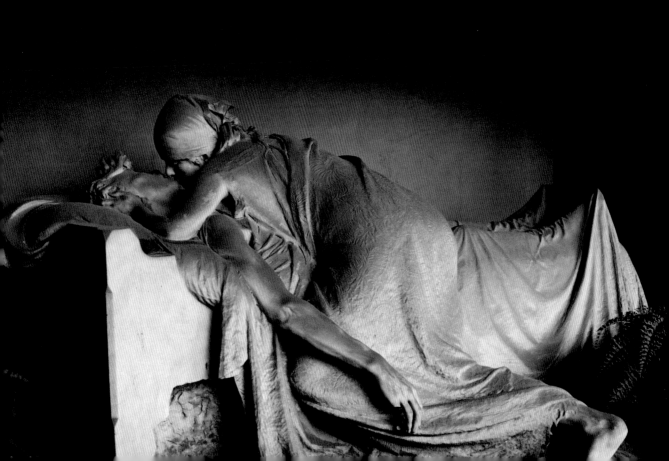

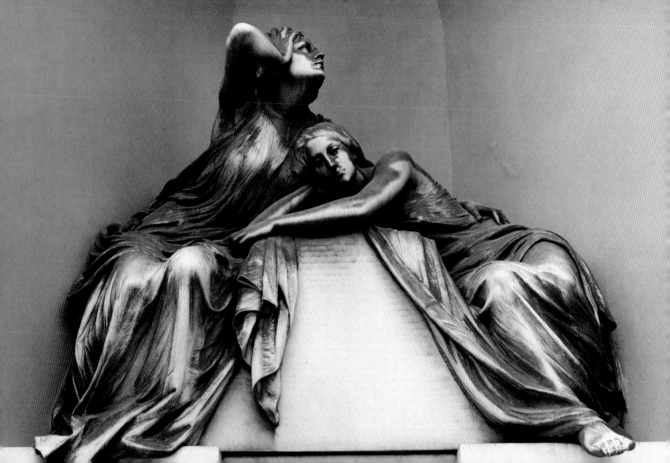

Rome, Campo Verano | Rome, Campo Verano

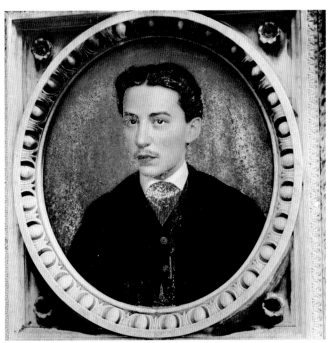
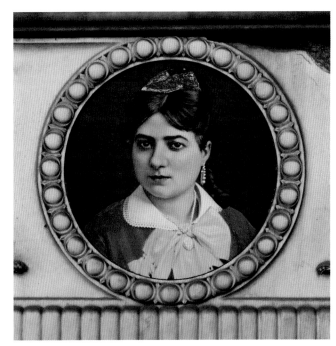

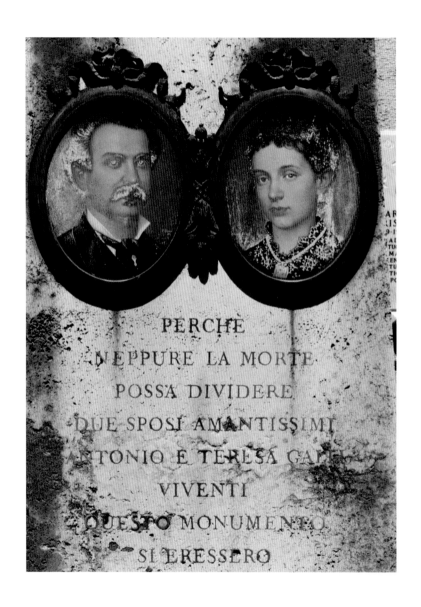

Rome, Campo Verano | Rome, Campo Verano

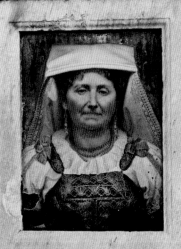

Ⲁ Ⲣ Ⲱ

MARITIANVS BARTHELI
CALLISTAE BV
VXORI PRAESIDET CASTAE
PIAE PVDICAE PRVDENTI
IMMATVRO FATO EREPTAE
XX KL IAN DISCEPTAVI
AET AN LVII
FERDINANDVS MARIA IACINTHA THOMASIA
MATRI AMANTISSIMAE
MOERENTES P

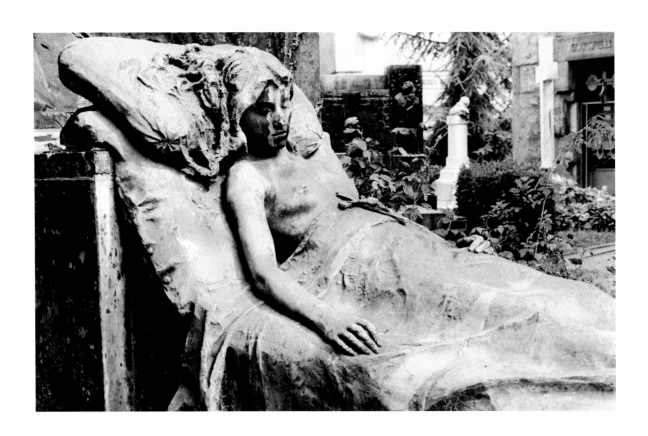

Milan, Cimitero Monumentale \ Milan, Cimitero Monumentale

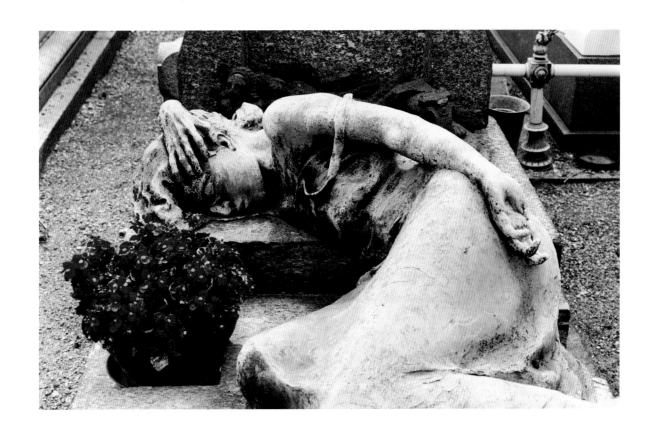

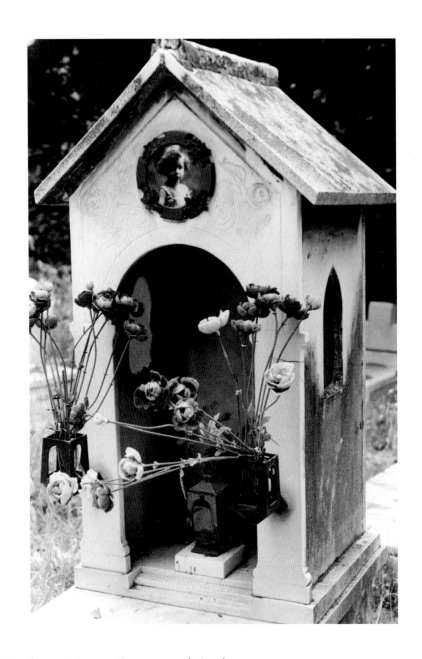

Genoa, Camposanto di Staglieno | *Genoa, Camposanto di Staglieno*

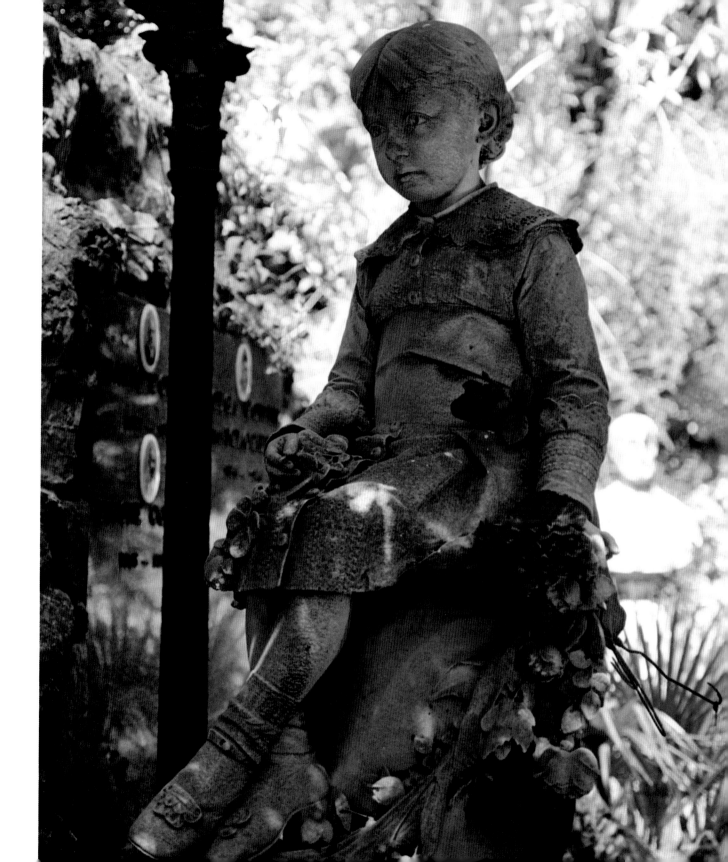

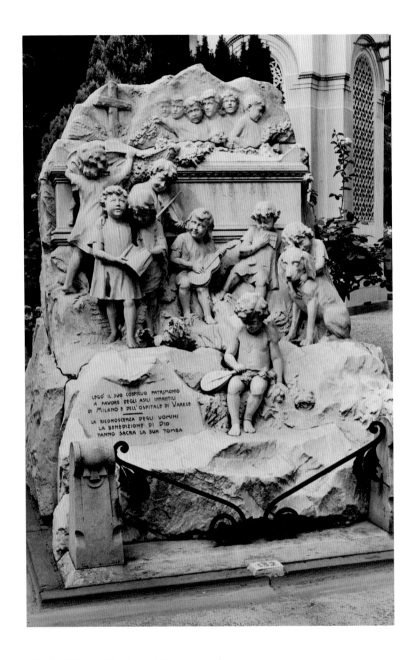

Milan, Cimitero Monumentale \ Milan, Cimitero Monumentale

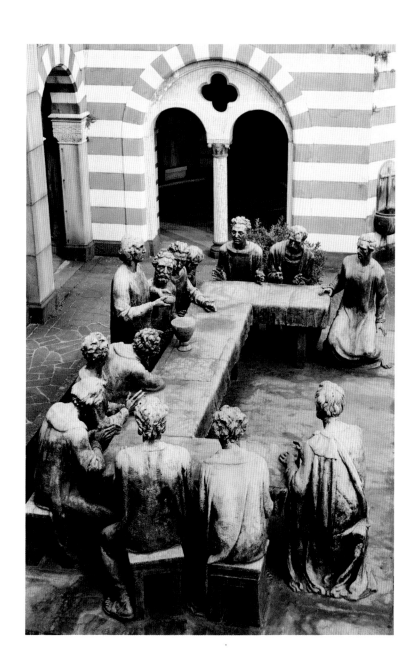

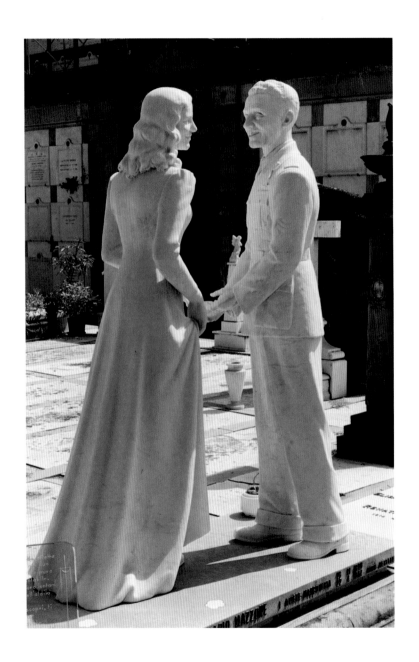

Florence | Milan, Cimitero Monumentale

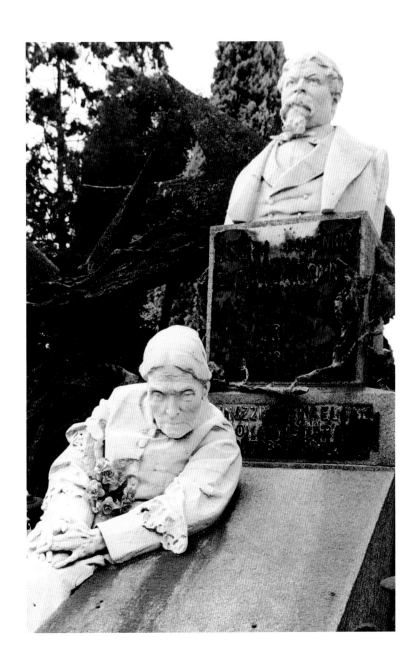

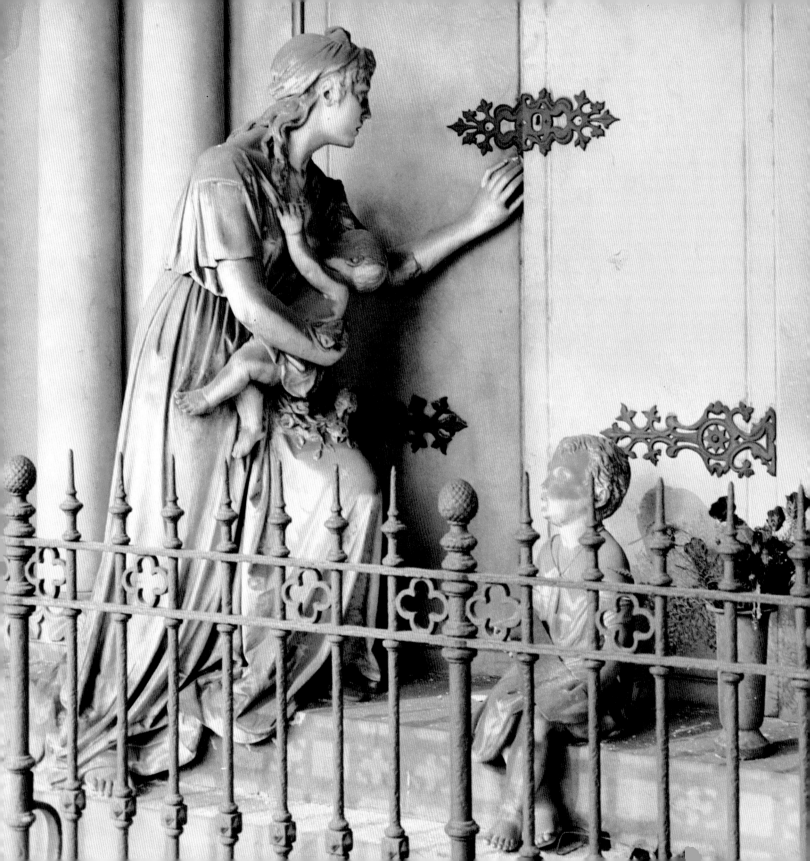

The Art of Commemoration in European Cemeteries

David Robinson

I

Although I did not know it at the time, this book began when I first walked into Père-Lachaise. Despite the reputation of this famous Parisian cemetery, which is what drew me there, I really knew very little about it. I went there like any of the other four million visitors each year, out of a vague curiosity. Thus, I was unprepared for what I found. The visual impact was immediate—monumental tombs lining broad cobblestoned streets, shaded by huge trees, are an impressive sight. I was

Milan, Cimitero Monumentale

drawn to the elaborate architecture of the old mausoleums and to the incredible array of art ornamenting the tombs, especially the statuary. Père-Lachaise, I was told later, represents the largest collection of nineteenth-century sculpture in the world.

My wife and I moved to Paris in November 1990, and I began to visit Père-Lachaise on a regular basis, gradually absorbing its grandeur and scale, and always finding something new and unexpected. Each visit further piqued my curiosity. Awe of the monumental gradually gave way to an appreciation of the subtle. It was when I got past the obvious that I became thoroughly seduced by Père-Lachaise. It was then that the idea of a book began to dawn.

As a photographer, I chose to deal with the vast totality of the cemetery by focusing on the intimate and telling details. In addition to the general ambience of the cemetery, it was the uniqueness of individual tombs that most intrigued me. Many tombs, whether simple or elaborate, were deeply moving in the sentiments they depicted. The personal expressions of love and respect for the departed took many forms, and I could only admire their originality and marvel at the creativity employed in the service of honoring the dead. I began to look closely, tomb by tomb, searching in the specific details for the answers to the many questions that flooded my mind. Cemeteries are conducive to meditation, and in this spirit my photographs are intended to be evocative rather than documentary. It was by photographing the tangible residue of sentiment that I could best feel and express the actual emotions surrounding death.

Cemeteries are really for the living and not for the dead; it is we who need them. And we need them for psychological reasons far more than for history: Cemeteries are more than stone ledgers, and the emotions expressed intrigue me more than the details of the lives recorded. What drew me so often to Père-Lachaise was not the pursuit of historical records but my deepening curiosity about the psychological mind-set that had spawned such glorious commemoration.

I came to believe that cemeteries celebrate not only lives past but lives yet to be lived—in

Milan, Cimitero Monumentale

eternity—and that the primary focus of the cemetery is not mortality (history) but immortality (hope). The temporal achievements cited merely point the way to everlasting life. Therefore, the primary purpose of the cemetery is to make the best possible case for immortality and to argue that case as eloquently as possible. Despite all the articulated grief, cemeteries strike me as places of optimism, not morbidity. In all my photographing, I never tripped over any bones or saw any bodies, hardly even a coffin. Only when I came upon a deathbed photograph of an old woman in Rome did I realize that all the photos I had seen in the cemeteries were photos of live people. The photo in Rome remains the only exception. In the cemeteries, death was much talked about but seldom seen.

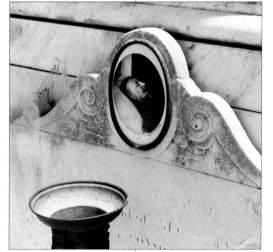

All the specific details of the tombs—the inscriptions, souvenirs and photographs, flowers and wreaths placed on the graves, the wrought iron, stained glass, and architectural details, as well as all the sculpture—are what I call traces of immortality, and this is what forms the raw material for my photographs. Vast sums of money were spent on commemoration, and high levels of creativity and craftsmanship were employed. Thanks to the sculptors who spared no effort in depicting both the heroism of the men and the grief of the women, we can still feel the emotions of pride and loss.

Cemeteries reflect the passage of time in many ways. In the older cemeteries, the poignancy of nostalgia is added to the rich mix of emotions. As a photographer, I respond to the weathered stones, faded colors, broken glass, and general disrepair of the tombs. Even artificial flowers fade and grow old, but in the process, they sometimes become more beautiful. I am aware of the irony of these permanent monuments to temporal lives themselves falling into decay. But just as we accept the aesthetics of Cubist collage, with its newsprint now yellowed instead of the original white, it is the old tombs with their crumbling textures that we have come to appreciate. These decaying stones seem more appropriate than the shiny indestructibility of the granite now commonly used for newer graves. In terms of photography, people usually think of cemeteries as a fit subject for black-and-white, but

one of the aspects of Père-Lachaise that initially surprised me was the faded palette and muted colors. I photographed in both black-and-white and color, but I came to love the expressiveness of the soft and subtle colors of the cemeteries; thus, most of this book is in color.

There are several guidebooks to Parisian cemeteries, and I began reading them and whatever else I could find on the subject. Paris was the cultural capital of Europe during the nineteenth century and has the tombs to prove it. Most guidebooks take the "homes of the stars" approach and emphasize the who's who and who's where of whatever cemetery. There are maps for celebrity tombs, and people from all over the world flock to Père-Lachaise and other major cemeteries to visit the graves of their heroes, whether they be poets or musicians, painters or statesmen.

I have my own set of heroes, and hero worship as evidenced by visitation to the grave is a fascinating phenomenon, but my major interest as it developed was commemoration rather than fame. I photographed without regard to fame or personal identity, and for this book I have generally selected photographs of graves of those who are not famous—not famous to me, that is; they may be well known and important to others. Since I was most interested in the personal commemorations, I found the random array of visual details more compelling than the systematic organization of historical facts, and I found it was not necessary for me to know the identities in order to respond to the feelings expressed.

In responding to the display of emotion, I also had to question the motivation—just why the Parisians had seen fit to put so much effort and expense into their tombs. Who exactly was the audience? And what specific purpose was served by these elaborate tombs? In the grandiose setting of Père-Lachaise, how could anyone reliably distinguish piety from ego? As I became increasingly curious, questions of this sort began to multiply and served to spur me on.

As my interest broadened, I began to explore other cemeteries; there are twenty-six in and around Paris, and I visited most of them. Those which were the most interesting to photograph besides Père-Lachaise were the cemeteries of Montmartre, Montparnasse, and Passy. All date from the early nineteenth century, but each has its own distinct personality, as well as many tombs of famous people and significant monuments. Montparnasse, as the cemetery serving the Left Bank, stands out from the others because it expresses the personality of the Left Bank, with a high number of idiosyncratic and unconventional tombs, both

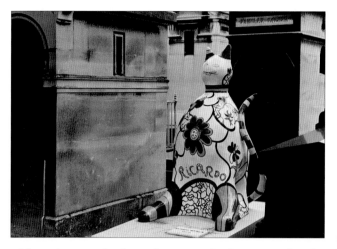

old and new. I also photographed cemeteries in several other parts of France, and traveled to other countries—England, Italy, Spain, Portugal, the Czech Republic, Slovakia, Austria, and Hungary. My exploration had become a quest, one that I followed for two full years; in the process I took about ten thousand photographs. In every cemetery I visited, I was able to find unique forms of commemoration to photograph, and I remain convinced that I will find something of interest in any cemetery.

Traveling to eight countries to photograph, I noticed striking national differences in the forms of commemoration, and I tended to concentrate on whatever I found unusual—the glass-enclosed wreaths in Portugal, the wall tombs in Spain, the personal epitaphs in England, and so on. Virtually every tomb in Italy has a photograph on it, and in Rome I found a section of large, hand-colored, and ceramicized photographs from the nineteenth century that would be a credit to any museum. The Jewish cemetery in Prague is crowded from centuries of use; tombstones from several layers of burial are all jumbled together. The stones are covered with Hebrew inscriptions and historical and laudatory epitaphs, and people still pay their respects to the dead of several centuries ago by leaving small pebbles and even notes on top of the tombstones.

Like local dialects, each region, not just each country, has its own visual language of mourning, which is apparent in broad outline immediately upon entering the cemetery gate. These regional differences are themselves fascinating, but following my primary interest in the individual graves, I continued to be drawn to the unusual tombs, the idiosyncratic rather than the normative. In every cemetery, no matter how universal the local visual dialect seems to be, some tombs always stand out. Someone always exceeds the norm or varies the form in an attempt to make that grave more personal. Often these are larger and more elaborate or contain more souvenir plaques, but there is also a smattering of homemade commemorations, what in the art world would be called naive art or *arte povera*. After a while, I began to call all these

Montparnasse

unusual tombs the soloists among the chorus, and these are the ones I chose to photograph.

Although my photographs concentrate on the individual as opposed to the group, and on the emotional rather than the historical, in an effort to understand the overall phenomenon I also began to study the history of European cemeteries. Reading the history has helped provide a context into which I can put my own explorations. Most of my reading postdated my photography; I was not aware of the history nor beholden to any theory while photographing. And, in fact, I try not to think very much at all while photographing; I prefer to respond to fresh visual stimuli rather than be restricted by predetermined assumptions. All my conclusions are based on my observations, amplified at a later date by reading. For the most part, the history I have read confirms the instinctive choices I made, but it has also given me a greater understanding of what I was photographing.[1]

II

The cemeteries that exist today in Europe and that first appeared to me to be so old are in fact relatively recent creations, which owe their origin to reforms enacted in the years following the French Revolution. Père-Lachaise was the first of the "modern" cemeteries and served as a model for scores of others all over Europe and in parts of the United States. Throughout the nineteenth century, new, large cemeteries were created *extra muros*—outside the walls—of the major cities. When it was founded, Père-Lachaise was outside Paris; the city has since expanded and now incorporates the cemetery.

I did not know this history when I started photographing, but eventually I came to realize that without the creation of these modern cemeteries and the reforms they entailed, the individual forms of commemoration that so interested me would never have developed. It was only later that I came to understand that Père-Lachaise and the other modern cemeteries represented a profound shift in the way people were buried and the way their memories were honored after death.

The Paris churchyard cemeteries that had persisted for a thousand years finally ran out of room near the end of the eighteenth century. And Les Innocents (transformed into the Catacombs), the huge central cemetery used as a supplement by all the churches, was closed in 1875 for health reasons; noxious odors and escaping gases caused people nearby to collapse. There was a fast-growing

awareness that the malodorous conditions that had been tolerated for so long by a quiescent populace could be the source of disease. But the closing of Les Innocents was followed by stopgap measures that actually made conditions worse. Burial had to be in hastily dug pits or distant fields, wherever space allowed. Bodies had to be carried through the crowded streets by hired porters, who frequently used the money for drink and could not be relied upon to carry out their unpleasant task. Often, bodies were wrapped in shrouds and just left on the surface of the earth to rot. Descriptions of burial conditions in late-eighteenth-century Paris make for gruesome reading, and today it is hard for us to imagine how the indignities suffered at the hands of drunken porters and the foul conditions of the old cemeteries—the anonymous pits, noxious odors, bones sticking out of the ground, and so on—could have been tolerated without complaint for so long. But finally, the rising awareness of health issues and fear of a new plague prompted calls for permanent reform.

People also came to protest the violation of the role of sanctuary that the cemetery had traditionally represented, and the lack of respect for the dead shown by the whole system of indifferent and callous burial. These concerns reflected a significant shift in popular attitude; neglect of the cemetery became synonymous with a lack of respect for the deceased that was no longer tolerable. People began to protest both the anonymity of the burial and the mistreatment of the body.

France was not the only country in which there were protests against existing conditions in the cemeteries, but France, already in the midst of social turmoil, was the first to officially address the problem. Some speculate that the Parisians' disgust with the grisly killings during the French Revolution speeded their desire to restore dignity to death. In any case, after several proposals, all of which called for creating large new cemeteries, the revolutionary government of France made provision for Père-Lachaise, and it was opened in 1804.

The nineteenth century saw the steady creation of cemeteries throughout Europe, inspired by Père-Lachaise. In Paris itself, two other large cemeteries soon followed; Montparnasse cemetery opened in 1824 and Montmartre in 1825. Père-Lachaise was to serve the eastern part of the city, Montparnasse the south, and Montmartre the north. In England, cemetery reform was part of the general Reform Acts of 1832, and the modern cemeteries of London date from this period: Highgate opened in 1836, Kensall Green in 1838, Brompton in 1840. Cemeteries in other cities fol-

lowed suit: Campo Verano in Rome in 1837, Staglieno in Genoa in 1844, Almudena in Madrid in 1877. I photographed in all these cemeteries.

Burial in large cemeteries on the outskirts became the accepted practice for large European cities, while churchyards continued to serve small villages. But the new system of burial adopted by the cities contained seeds of change that went far beyond matters of public health. Since Père-Lachaise was the first modern cemetery and the model for the others, it is instructive to examine the reforms it represented.

Père-Lachaise was a public cemetery—that is, it was under the supervision of the municipality, not the church. It was open to everyone, whether Catholic, Protestant, Jewish, or nonbeliever, in different areas. There had been problems with the church restricting certain burials in the consecrated ground it controlled; priests had on occasion refused to bury suicides and stillborn or otherwise unbaptized infants. A mother and child having died together in childbirth could not be buried together. Families risked being torn apart by religious rigidity, and this came to be seen as a grievous affront to the sanctity of the family. The new system of burial had the effect of emphasizing family rather than religion.

Since the new cemeteries were so far outside town, the old practice of hired porters was scrapped in favor of horse-drawn hearses, which carried the body with dignity as well as certainty that they would deliver the deceased to the gravesite. The funeral in the church was separated from the burial in the cemetery, and, as a result, the church's control over burial rituals was weakened considerably. Although religious rituals persisted at the gravesite, the church could no longer dictate behavior as it once did. Burial became more secular. Reflecting the strong anticlerical atmosphere of the Revolution, some of the early reform proposals had called for cemeteries completely free of religion, going so far as banning crosses and religious symbols altogether and replacing them with the neutral symbol of the recumbent figure. Although this extreme proposal was never adopted, the image of the sleeping figure—and the concept of death as rest—is one of the most common symbols found in Père-Lachaise and other European cemeteries.

In my opinion, the secularization of the cemetery was a major factor in the development of new forms of commemoration, which make Père-Lachaise and the other modern cemeteries so diverse and so interesting. There was a growing need to give expression to one's personal emotions, which the traditional rituals could not adequately

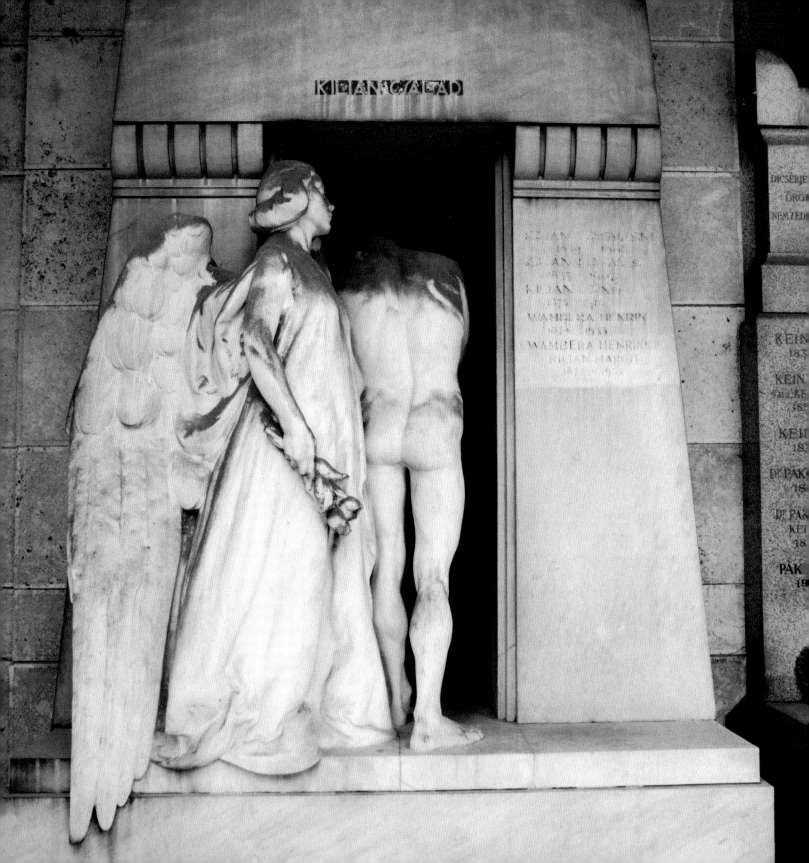

accommodate. As popular emotions surrounding death were changing, the accepted forms of honoring the dead also underwent changes, and these were facilitated by the new municipal cemeteries. In the course of my photographing, it became apparent to me that where the church link to the cemetery remained the strongest, as in Spain or in small towns, the variation in personal commemoration was the least developed.

The cemetery reforms of the nineteenth century required individual burial—there were to be no more mass graves. This was the second factor that opened the way for individual commemoration and personalization of the grave. It was nominally done for health reasons—to prevent the spread of disease—but the law also reflected the changing public sentiment toward the dead. In Les Innocents and the stopgap cemeteries that succeeded it, there were no individual markers, and it was impossible to know where a particular body lay. The law creating Père-Lachaise specifically provided for "a distinct and separate place where people can establish graves for themselves, their relatives, and heirs, and where they can construct vaults, monuments, and tombs." Long-term leases—grants in perpetuity—were also provided for.[2]

Permanent plots made elaborate monuments and mausoleums a realistic proposition. For those who could not afford a grant in perpetuity, renewable short-term leases were created, and some form of marker could thus be erected. Individual burial, personalization of the grave, grants in perpetuity, and the right to erect monuments all combined to shape a public display of familial commemoration. In the modern secular cemetery, the cult of the dead became the major religion, and this depended on being able to locate, identify, and mark the individual grave. With family plots, family identity was strengthened and proclaimed.

It was the middle class that most enthusiastically embraced the monument, and this is the third factor that shaped Père-Lachaise and the other modern cemeteries. If commemoration was no longer restricted by the church, neither was it constrained by class. In the churches, only the aristocracy had been allowed any sort of monument. But the nouveaux riches who were prospering in an expanding economy recognized in the commemorative monument a means to validate their success and to establish the family reputation in the larger society, and in the bargain gain access to eternal life. They brought great energy to the task, and they were willing to lavish a great deal of money to accomplish their objective.[3]

The rush to commemoration did not happen

immediately, however, and not without some clever marketing. To set a public example, in 1818 cemetery officials had the famous lovers Héloïse and Abélard, dead since the the twelfth century, dug up and reburied in an elaborate tomb and a place of honor in Père-Lachaise. The officials did the same for France's two greatest seventeenth-century writers, La Fontaine and Molière, who also had been resting elsewhere. As the idea of personal graves grew, the race for commemoration was on. By 1823, an estimated forty percent of graves in Paris had monuments. This represented a tremendous psychological journey, far from the passive acceptance of the anonymous pits only a few years before.

Individual burial necessitated the establishment of very large cemeteries. Also, in order to escape as far as possible from the noxious burial pits of the city, the new cemeteries were originally conceived as boundless country parks, or garden cemeteries, which would be planted with beautiful trees and flowering shrubs, thus creating places where the deceased could find peace in the bosom of nature and where visitors could stroll and meditate and draw inspiration. Père-Lachaise is still the largest open space in Paris, larger than the Bois de Boulogne and the Bois de Vincennes. After several expansions up to 1850, it reached its present size of approximately one hundred acres. But the original concept is no longer evident in Père-Lachaise. The rush to commemoration, which far exceeded the wildest dreams of its promoters, eventually transformed Père-Lachaise from a garden cemetery to a mini-city. Today it has the look of a crowded Lilliputian town full of stone houses cheek by jowl along cobbled and curbed streets with street signs and even neighborhoods (divisions). Père-Lachaise has become the epitome of the urban cemetery. It retains the steep hills and the trees, now grown enormous, but little else of the original feeling of being at one with nature. Now the beauty of Père-Lachaise is man-made, and its attraction is art and architecture rather than nature.[4]

As part of the cult of the dead, visitation was encouraged right from the start, and as early as the 1860s, an average of 70,000 people per week were visiting the Parisian cemeteries to pay their respects to loved ones or draw inspiration from both the art and the nature that coexisted there at the time.

Instinctively I chose not to photograph official or state tombs, such as those in the Panthéon or Saint-Denis or Westminster Abbey, places where a nation's kings and heroes are buried. I decided so partly because their tombs are indoors, but primarily because they seemed too predictable. Official

monuments hold little interest for me. Neither did I choose to photograph churchyard cemeteries, except when I found myself in small towns where the parish cemetery was the only cemetery. Instead, I concentrated on large cemeteries like Père-Lachaise, because they are so diverse and seem so much more alive. It is in these modern cemeteries that one can observe not the kings but the common citizen. Most are still in use, and it is in their milieu that one can best view the individual and the collective quest for immortality as it existed in the nineteenth century and as it continues today.

III

From the beginning, I was curious what motivated people to create such lavish commemorations. As I observed the scale and grandeur of so many monuments, my initial assumption was that ego—monumental ego, one might say—must have been the driving force behind these monuments, that men must have ordered their own tombs so as to solidify their position both in society and in the life to come.

But Philippe Ariès has caused me to revise my early assumptions. He makes the point that the physical changes in nineteenth-century burial were matched by a psychological shift that was even more profound. Ariès writes, "A revolution in feeling seized the West and shook it to its foundation." In what he terms "the sense of the other," affectivity and emotion regarding death were no longer centered on oneself nor on the community but on the family: "The fear of death . . . was transferred from the self to the other, the loved one."[5]

It follows that it was concern for the family, not for oneself, that spurred and justified the building of lavish commemorative tombs. The ego that was involved was in the name of the family. Although in the tradition of Christian humility one might specify a plain and simple grave for oneself, a loved one deserved better. Love dictated an appropriate monument, if not the best money could buy. Not to provide a monument consistent with and expressive of one's love, a monument befitting the deceased's social standing, good deeds, and personal qualities, would be a virtual admission of indifference. This kind of insult to the good name of the family would have been unthinkable in the nineteenth century. Hubris was incorporated into the family, domesticated. By honoring their families, men got their monuments.

As I said earlier, I believe these monuments were geared to the future as well as to the past and represented an attempt to gain recognition in

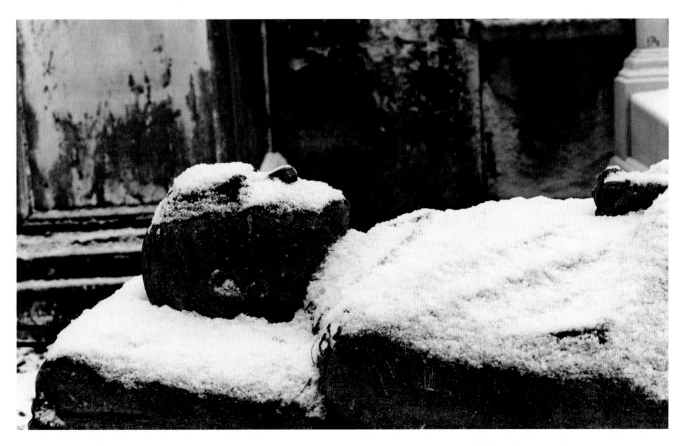

heaven as well as in society. They were based on a belief in the afterlife, and the stronger this belief in immortality, the more death was depicted as positive. The horrific images of death that were typical in previous centuries were replaced by images of peaceful repose—the beautiful death. Whereas piety and a desire for eternal life might lead one to admonish oneself with the awful reminders of damnation, the prospect of hell or even purgatory was too much to contemplate for a beloved rela-

tive. The vision of life after death was made over into a positive image to suit the love one had for "the other," the loved one.[6]

The emerging picture of immortality incorporated several positive symbols. The first was nature: As mentioned previously, the original conception of the modern cemetery was that of a lush garden. One source for this inspiration was Jean-Jacques Rousseau, who had preached the purity of country life as the antithesis of the corrupt city and

Paris, Père-Lachaise

whose own grave, set in the natural beauty of the countryside, had become an exalted place of pilgrimage. In the new cemeteries, visitors were supposed to draw inspiration from the natural setting as well as from the gravesite—even to the point of envying the dead for residing in such a glorious environment.[7]

Another important symbol was that of the sleeping figure. Death was pictured as peaceful repose in a natural setting. The concept of death as sleep was not new, but in the concept of beautiful death, sleep became not only peaceful but restorative. The emphasis on family affection led to faith in the certainty that all the family members and loved ones would be reunited in the afterlife. Therefore, sleep was temporary, until we met again; one would be awakened by a reunion. It follows that if death was not final, it was not ugly. The beauty of the body was replaced by the beauty of the soul, which was eternal and could not decay.

In the nineteenth-century romantic view of death, it was not death per se that was mourned but the intolerable, albeit temporary, separation from the loved one that death caused. The exquisite sadness depicted on so many tombs was the extreme grief of impermanent loss, like a wrenching goodbye at a train station. It was the separation and not the destination that animated the emotions. Belief in immortality promised reunion with the departed, who was now waiting tranquilly, and that faith was kept alive by active remembering—commemoration. "How sweet is that immortality which begins in this world in the hearts of those who miss you."[8] Invoking the memory of the departed also helped conquer the fear of death, and as long as memory was kept alive, death was kept at bay. Real death is anonymity—when survivors forget or die themselves. So all the various forms of commemoration also helped keep the loved ones alive—in one's consciousness.

Images of eternal togetherness abound in the cemeteries: images of families posing together, the symbol of joined or clasped hands, or the treacly sentiments of souvenir plaques and floral wreaths. Judging from more recent graves, people continue to place their faith in some form of life after death. Although today's commemorations are not as elaborate nor individually crafted as those of the nineteenth century, they do signify a continuing belief in eternity. That has not changed in the period of almost two hundred years encompassed by the European cemeteries I photographed, and that is an impressive record. Cemeteries continue to be proclamations of optimism as well as sorrow.

But the question remains: After spending so much creative energy and money, is all this com-

memorative effort convincing? Perhaps. And thanks in large measure to the very things I have been photographing, it may have been easier in the nineteenth century to believe in eternal life. In the cemeteries of that era, as in the movie theaters of today, one was encouraged to suspend disbelief. Like a darkened theater, the walls of the cemetery create a special enclosure conducive to active imagining. This atmosphere of fantasy—of "extreme and unrestrained imagination," as defined by the dictionary—is one reason I respond so positively to the European cemeteries.

IV

During the time I spent photographing in Père-Lachaise and other European cemeteries, I observed many hundreds of people visiting various gravesites. Although the cemeteries date from the nineteenth century, most are still in use. Thus, in addition to the graves of famous people, the cemeteries also contain family plots still frequented by relatives. Two types of pilgrimage were readily apparent to me: visits to the grave of a loved one and visits to the grave of a hero. Although these graves could actually be adjacent to one another, I could see that each type of visitation is very different from the other.

The element they share is that by going to the gravesite, a special bond is formed or reaffirmed. Whatever takes place through this visit evidently does not or cannot happen elsewhere.

As I mentioned in the beginning, I too have my heroes—primarily Impressionist and Post-impressionist painters—and I have enjoyed the satisfaction of searching for and then finding their graves, often in out-of-the-way places. So, I have experienced as well as observed this type of pilgrimage. For those who search out the graves of their favorite authors, musicians, or artists—people known only by reputation or through their work—visitation to the hero's grave bestows authenticity upon that person's work and life by certifying that the hero is not fictional. Standing before the grave confirms that he or she actually existed, and, as a result, the person's work seems even more profound and remarkable. Everything you know about that person is brought into focus, confirmed, and validated. Whether the graves are simple or elaborate, this type of visitation is immensely satisfying. I have never seen any sadness at the graves of heroes.

I have also watched relatives visiting family graves, which is another matter entirely. These are intimate visits full of emotion; few of us ever visit the graves of relatives we have never met or do not

care about. I have seen women wailing and thrashing over the graves of recently deceased loved ones, and sometimes the expression of their grief is overwhelming. In Europe there is a tradition of visitation; some people make regular trips throughout the year, and many graves are continually maintained with fresh flowers. (If the family members cannot do it themselves, they sometimes hire caretakers to do so.) But most family visits occur on special occasions—the birthdays or anniversaries of marriages or deaths of those who were known and loved.

Visitation to the grave of a loved one is both an occasion for and an inducement to memory. It is a time to mourn and to meditate, which by numerous accounts often takes the form of personal conversations with the deceased. There is a place as well as a time for every purpose under heaven, and the place deemed most appropriate for mourning is the cemetery. Visitation to the grave of a loved one renews personal bonds in a way that a photograph on a table evidently cannot.

I confess that before photographing in the cemeteries, I never thought a gravesite was a necessary stimulus to memory. My fascination with the phenomenon, which grew as I spent more time in the cemeteries, may be due to the fact that I have never personally experienced it. By their choice, which I accepted without question, neither of my parents has a grave. They never discussed their decision to join the memorial society with me, and I would never have thought to bring it up. If my father took my mother's ashes, he never mentioned it. And I saw no reason to take his when asked, because I never believed that the absence of a physical marker, whether an urn or a gravestone, would prevent me from remembering him. And it has not; I think of my parents often during my daily routines and at unexpected moments, which I treasure more because they are spontaneous rather than planned.

When Aaron Siskind died and chose not to have a grave, a mutual friend bemoaned after the funeral that "there is no place to go" to grieve. I did not fully share his concern at the time, but in the course of doing this book, I have come to understand in a way I never could before the value of a gravesite.

For one thing, I now understand that remembering is not the same as grieving any more than thinking is acting. As I write this, I am forced to admit that although my parents have been in my thoughts almost daily in the eighteen years since my mother died and the fourteen since my father died, I have not truly mourned them, nor have I been able to come to terms with losing them.

Maybe a grave to visit would have helped. One of the lessons I have learned is that grief needs to be ritualized to be effective. One of the most powerful rituals of mourning is the visit to the gravesite.

Moreover, I also realize now that, when I am gone, my parents will be dead. There will be no one alive who can remember my mother's laugh or my father's singing—and there will be no one left to tell the important story of their lives. The same is true for all of us, and that strikes me as life's greatest tragedy.

Establishing the family record seems important to me now. I want to write my family history. I have come to realize that I know very little of my father's ancestry, in part because I do not know where his parents are buried. I have visited my mother's family plot in Freedom, Wisconsin, and thus have been able to confirm and fill in her childhood stories. As a result, I feel more connected to these forebears; as long as the family chain endures, each link continues to have some meaning. Within the family, we can rest assured that we will have contributed to the future through our very existence if in no other way.

Only with the growing awareness of my own loss, which was animated by my work in the cemeteries, have I in turn been fully able to appreciate the emotional underpinnings of the elaborate nineteenth-century commemorations I have photographed—the grief for "the death of the other," the anguish of separation, and the eloquent striving to make the best possible case for immortality. Cemeteries help assuage survivors' grief through commemoration and by establishing a public historical record. No amount of personal remembering can last forever, and I have now come to realize the limitations of purely private mourning. In the end, I think that immortality by definition must be a public phenomenon. Families in Père-Lachaise and other nineteenth-century cemeteries were making a public record of their private grief, and this is what all cemetery commemorations do.

Cemeteries are only one way in which people seek to overcome their mortality. Wealthy people leave endowments, and creative people strive for immortality through their work. By dedicating this book to my parents, I am in effect creating the epitaph denied them in the cemetery. And, by seeking to establish a public achievement in my name that will endure after I am gone, I am hoping to create a building block of my own immortality as well. That is the artist's quest. In this sense, museums are the artists' cemeteries. Likewise, authors have libraries, where they continue to live on in the yellowing pages of dusty volumes and in the possibility of discovery by new generations.

Almost all of us can create some monument or commemoration, no matter how humble, so that at the very least our names or those of our loved ones will be recorded. But there are no guarantees that any commemoration will last or, if it does, that anyone will discover one's creative work, family record, or life's story—or that if they do, that they will care. One's faith in immortality is in the end the hope that someone will notice, that someone will remember.

Does that mean that I believe that all who have invested in elaborate commemorations have been deluded? Not at all. Once again, we should remember that, despite the conventional wisdom, cemeteries exist for the living, not for the dead. Although commemorations are created in the name of the deceased and with the rationale of preserving a record for posterity, they really are for the benefit of the survivors. Right from the beginning, I recognized that cemeteries looked ahead as much as they looked back. And, I soon came to understand that graves are therapeutic as much as they are historical. The twin concepts of the beautiful death and of everlasting life—given such magnificent form in the European cemeteries of the nineteenth century—are ways not only to reconcile oneself to the loss of a loved one but also to reassure oneself about one's own immortality.

There are lessons for all of us in visiting these cemeteries or looking at these photographs. Memories of our own families and loved ones come flooding back to us. And, the nineteenth century does not seem so remote or so different. Although elaborate tombs in the nineteenth-century style are beyond our reach, we can still draw inspiration from them. They remind us that we have the freedom to find or create new forms of commemoration, no matter how grand or humble, which are appropriate to our own circumstance and philosophy and which do justice to those we love.

We will continue to look to the nineteenth-century European cemeteries for artistic beauty and for inspiration. We will continue to find there the enduring hope and unqualified optimism about eternal life. Thanks to the European cemeteries represented in this book, the persons honored in them have indeed achieved their immortality. And, even more important, the very concept of immortality, because it was so exquisitely rendered and eloquently proclaimed, also remains alive for us today.

1. For my study of the history of European cemeteries, primarily Père-Lachaise, I am particularly indebted to the French historian Philippe Ariès, who has traced several centuries of burial practices, and to the books by Richard Etlin and Thomas Kselman cited in the bibliography. Most of my conclusions in the following sections are based on the carefully researched and well-written histories provided by these three men. In addition, I have consulted the guidebooks and general works also cited in the bibliography.

2. Thomas A. Kselman, *Death and the Afterlife in Modern France* (Princeton, N. J.: Princeton University Press, 1993), p. 183.

3. Although the modern cemeteries were open to the poor, the poor could not afford elaborate tombs. The cemeteries, therefore, although more egalitarian, still mirrored the class structure of the society at large.

4. The English cemeteries retain more of the garden atmosphere. There are fewer mausoleums, more open space, and simple rounded vertical stones rather than the larger tombs of the French cemeteries. While many of the French tombs have decayed over time, many of the English cemeteries are overgrown with vegetation, giving them a decidedly rural look. Although it is outside the scope of this book, the cemetery that remains the epitome of the original garden cemetery is Mount Auburn Cemetery in Cambridge, Massachusetts, opened in 1831.

5. Philippe Ariès, *The Hour of Our Death* (New York: Oxford University Press, 1991), pp. 609-610.

6. One can find macabre images of skulls and skeletons in the cemeteries, but they are in the minority. Cemetery imagery borrows freely and eclectically from the past, including Greek statuary, Christian themes, copies of classical works, and sometimes the grotesque. But there is no mistaking the general positive image of death in the cemeteries of the nineteenth century.

7. Ironically, in what seems a misguided effort to honor him, Rousseau was later uprooted and moved to the Panthéon.

8. Ariès, *The Hour of Our Death*, p. 415.

Bibliography

Ariès, Philippe. *The Hour of Our Death.* New York: Oxford University Press, 1991.

———. *Images of Man and Death.* Cambridge: Harvard University Press, 1985.

Barker, Felix, and John Gay. *Highgate Cemetery, Victorian Valhalla.* London: John Murray, 1888.

Barozzi, Jacques. *Guide des cimetières Parisiens.* Paris: Editions Hervas, 1990.

Broyard, Anatole. *Intoxicated by My Illness.* New York: Clarkson N. Potter, 1992.

Chabot, André. *Erotique du cimetière.* Paris: Henri Veyrier, 1989.

Culbertson, Judi, and Tom Randall. *Permanent Londoners.* Chelsea, Vt.: Chelsea Green Publishing Co., 1986.

———. *Permanent Parisians.* Chelsea, Vt.: Chelsea Green Publishing Co., 1986.

Curl, James Stevens. *A Celebration of Death.* London: B. T. Batsford, 1993.

Etlin, Richard A. *The Architecture of Death: The Transformation of the Cemetery in Eighteenth-Century Paris.* Cambridge: M.I.T. Press, 1984.

Hudson, Kenneth. *Churchyards and Cemeteries.* London: The Bodley Head, 1984.

Jaquin-Philippe, Josette. *Les Cimetières artistiques de Paris.* Paris: Librairie Léonce Laget, 1993.

Jolas, Jean-Louis. *Père-Lachaise, Théâtre d'ombres.* Paris: Maison Rhodanienne, 1990.

Kastenbaum, Robert, and Beatrice Kastenbaum. *Encyclopedia of Death.* New York: Avon Books, 1989.

Kselman, Thomas A. *Death and the Afterlife in Modern France.* Princeton, N. J.: Princeton University Press, 1993.

Le Clere, Marcel. *Guide des cimetières de Paris.* Paris: Guides Hachette, 1990.

Marion, John Francis. *Famous and Curious Cemeteries.* New York: Crown, 1977.

Mellor, Hugh. *London Cemeteries.* Amersham, England: Avesbury, 1981.

Nuland, Sherwin B. *How We Die.* New York: Alfred A. Knopf, 1994.

Pierard, Marie-Laure. *La Cimetière Montparnasse: Son histoire, ses promenades, ses secrets.* Paris: Michel Dansel, 1983.

Palmer, Greg. *Death, the Trip of a Lifetime.* San Francisco: HarperCollins, 1993.

Ragon, Michael. *The Space of Death: A Study of Funerary Architecture, Decoration and Urbanism.* Charlottesville: University of Virginia Press, 1983.

Ruby, Jay. *Secure the Shadow.* Cambridge: M.I.T. Press, 1995.

Shushan, E.R. *Grave Matters.* New York: Ballantine Books, 1990.

Schwartzman, Arnold. *Graven Images.* New York: Harry N. Abrams, 1993.

Vilimkova, Milada. *The Prague Ghetto.* Prague: Aventium, 1993.